7/21
4.50

PAINTING
WITH
COMPUTERS

First published in the United States of America by:
Rockport Publishers, Inc.
146 Granite Street
Rockport, Massachusetts 01966-1299
Telephone: (508) 546-9590
Fax: (508) 546-7141

Distributed to the book trade and art trade in the United States by:
North Light, an imprint of
F & W Publications
1507 Dana Avenue
Cincinnati, Ohio 45207
Telephone: (513) 531-2222

Other Distribution by:
Rockport Publishers
Rockport, Massachusetts 01966-1299

ISBN 1-56496-212-1

10 9 8 7 6 5 4 3 2 1

Art Director: **Lynne Havighurst**

Editors: **Don Fluckinger and Shawna Mullen**

Digital Editor: **Kathleen Kelley**

Cover Art: Bottle and Flowers: **Dennis Orlando**
 Genesis Two: **Mario Henri Chakkour**
 Back of the Bus: **Henk Dawson**
 Dock with Colorful Boats: **Dennis Orlando**

Designer: **CopperLeaf Design Studio, Inc.**

Manufactured in Hong Kong by Regent Publishing Services Ltd.

PAINTING
WITH
COMPUTERS

ROCKPORT PUBLISHERS
ROCKPORT, MA

INTRODUCTION

In *Painting with Computers*, Mario Henri Chakkour has written a book for traditional artists wishing to incorporate the computer into their workspace and to use it as an additional tool in the production of their art. The powerful and accessible computers of today are making their way into the studios of visual artists who previously dismissed them as potentially interesting, but lacking the quality and ease necessary to make the steep learning curve worthwhile. Artists are now intrigued by the potential of software, hardware, and peripherals to enable the realization of their artistic visions and perhaps to stimulate them to new and more powerful visions. They will welcome a book such as this to embark on their quest toward mastery.

My involvement with painting, computers, and education has been entwined. Originally trained as a painter, I have been involved with computers since the mid-1960s, when I was introduced to the IBM 360 as a tool for statistical analysis while working on my D.Ed. at The Pennsylvania State University; I used one of Apple's first computers with Visi-Calc and, soon after, Dazzle Draw; a Mindset, bundled with Lumina; an AT&T 6300 with TARGA Board and TIPS with Xeroxed manual; an Amiga 2000 emulating both Mac and IBM; and currently a Mac 8100/100. For nearly thirty years, as an administrator, teacher, and artist, I have used the computer for a wide range of purposes, including my primary art-making tool, and have shared my knowledge and enthusiasm with anyone I could persuade to listen.

My work, like many other artists who think of themselves as painters, is two-dimensional. The work on the computer is printed, usually large scale on canvas, and further worked with materials such as gold leaf. The term *tradigital*, coined by Judi Moncrieff to describe this kind of work, seems especially descriptive. A true mega-tool, the computer replicates the characteristics of traditional media and presents a range of effects and options available in no other way. If I could keep only one tool, it would without question be the computer.

Painting with Computers heralds a new era for artists, one which author/educator Pat Johnson has described as a "digital renaissance." The continued advancement of technology, coupled with the increasing visualization of the information revolution, makes this the most exciting time in which to be alive, and especially to be a digital artist. By writing this book, Mario Henri Chakkour has given all artists an invitation, and a guide to participation.

—Dorothy Simpson-Krause

Dorothy Simpson Krause is a Professor of Computer Graphics at Massachusetts College of Art, Corporate Curator for IRIS Graphics, Inc. and a member of Unique Editions, a tradigital collaborative.

Artists often experiment. This process involves a balancing act between the artist's likes and dislikes, the market's needs, and the idiosyncrasies of the media. *Painting with Computers* is a celebration of the *traditional* methods of creating art, married with the latest computer technology. This book does not advocate the use of the computer as a substitute for other media, despite the use of traditional terms or metaphors to describe digital tools. Although the computer can mimic charcoals and oils, it cannot replace them: Digital media should be used for their own sake.

Painting with Computers will aid those who never have used the digital medium as well as those who have. Beginners will benefit from easy-to-understand visual instruction, showing how traditional processes and new tools can be combined to create paintings, illustrations, montages, renderings, animation cels, and everything in between. By seeing how it is done, artists can apply and build their technique. Professionals will find this volume helpful because it complements computer manuals by offering tricks of the trade, not just a technical explanation of a particular software application's feature set. In all, this book shows that one can transcend the machine and become one with the art by demonstrating how an artist paints a digital image using familiar, traditional steps that have been used for centuries before artists were given CPUs, pressure-sensitive drawing tablets, or even RGB monitors with which they could create their works.

All it takes is a little bit of adjustment, such as learning to draw and paint while looking at the screen. It might feel awkward at first, but so was learning to walk and to ride a bicycle. In fact, once you learn to paint using the digital tools, the rest is easy!

Painting with Computers brings the trials and rewards of traditional craftsmanship to the computer's cold realm. Although the computer makes the process of artistic expression easier, the goal is to develop methods that offer opportunities beyond what each digital tool can do by itself. This is the essence of creativity.

That is why this book is concerned with creating the most out of the least, without filters. Such eye-catching special effects flooded the digital art scene with a legacy that is mainly a celebration of the machine, the software engineers, and the master printer. But what about the artist? While digital painting cannot happen without a team of experts constantly refining the environment, it should also be a celebration of the artist whose need for self-identity and originality is essential. *Painting with Computers* echoes this belief throughout its pages, while paying homage to the more technical-minded souls who made it possible.

—Mario Henri Chakkour

Dedicated to Dahesh, a great patron of the arts.

CLICKING AROUND

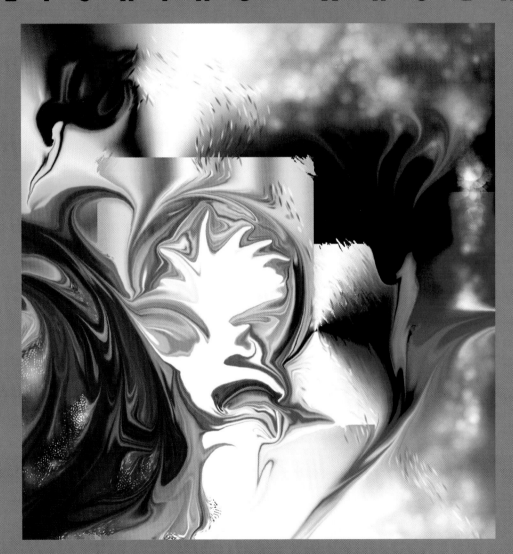

THE VIRTUAL STUDIO

Liberty John Sledd

■ Clumps of paint on a canvas are just that. Yet when viewed by the eye, the mind interprets these clumps of paint as of tension, order, balance, shape and form, harmony, or agony.

Creating art on the computer is as natural as walking; however, neither is easy in the beginning. The initial feeling one gets when faced with the prospect of painting with computers—technically termed creating bitmap or raster images—varies from person to person. In most cases, the typical reaction is "This can't work! Where are the paints, canvases, and brushes?" The answer to these questions is, *it's all in the mind.*

When training airplane pilots in the flight simulator, it is crucial to connect the experience of flight to the illusion of flight reflected in the instrument panel. Likewise, artists can express themselves using the virtual world of the computer: Through exercise and repetition, one can transcend the mere act of drawing while looking at a computer screen and feel the same range of emotions usually associated with traditional media. In time, one can almost feel the computer's simulated tools scrape or see the paint and water mix.

Step-by-Step

Virtual Studio

Software: The exercises in this book were created mainly in Fractal Design's Painter 2.0 X2 and 3.0, and 3.1, Pixel Resources' PixelPaint Pro3. Why use different versions of Painter? Just because a software is upgraded does not necessarily make it perfect. While many improvements are implemented, often they are made at the expense of other idiosyncrasies the artist spends months getting used to. Also, not every system can run Painter. That is why PixelPaint is used. Designed to be sleek and light, this product delivers power even on more modest computers.

Welcome to the virtual studio. Pull up a chair and get comfortable: The journey is about to begin! All that is needed is a Macintosh or PC-compatible computer system, a bit of patience and a lot of faith. Install and open any painting software. Click around and paint some colors, mix them, get the feel for this new environment. Start anywhere. Get acclimated to this new feeling; the skill will come next. A graphics tablet and pen are not the only tools with which to paint with computers. The mouse certainly can be part of that process, as well as the keyboard. Painting with computers is the act of generating and manipulating elements and pixels.

The most basic way to create a dot is to click the tablet surface once, or position the stylus (pen point) on the tablet using a light, jiggling motion to activate the pixels and build from that. Also, when drawing lines, start the movement before touching pen to tablet. Go ahead and "blob" some digital paint on the screen.

Digitizing Tablets

The paintings in this book were all created with the aid of the Wacom ArtZ tablet and its cordless pen. Although its 8.5" x 6" drawing surface is small the ArtZ or any comparable product on the market is more than adequate to create a high level of detail.

This tablet's performance was fine-tuned via the Wacom Tablet Driver. In this case, the "Orientation" was set to Landscape and the Aspect was set to To Fit. In general, do not worry about drawing in scale since the magnification is bound to change throughout the painting process. Paint by feel; never look at the hand.

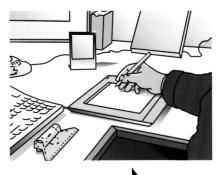

Step 1

If using a tablet, note that it can be placed to the side of the keyboard as illustrated. Hold the pen as if writing. Also, note the tablet does not have to be the largest—a 6" x 8" tablet can be as effective, if not better, than a 12" x 12" tablet. The larger the tablet, the more distance the hand needs to move to cover the screen. Consequently, the pen will become sluggish when sketching, so experiment with various tablet settings using the tablet driver software. Painting intricate details when using a small tablet will be dealt with later in the book.

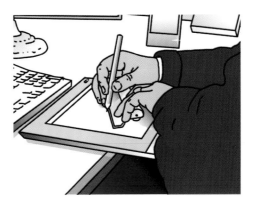

Step 2

Draw some straight lines. The best way to draw straight lines is to use a Rolling Edge tool as shown in the illustration, which makes it faster and easier to control the thickness of the line by applying varying degrees of pressure on the tablet. The Draw Straight Lines option in most painting software does not allow that, so this quite effective workaround is used. Artists can draw precise curved lines with the aid of a French Curves tool, which is used in the same fashion as the ruler, although this requires some patience to develop the proper hand-eye coordination. Drawing lines freehand is also commonly done.

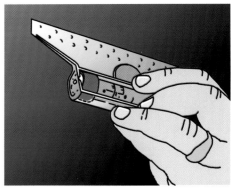

Step 3

Rolling edges are perfect for drawing parallel lines with the pen. The illustration shows a typical 6-inch rolling edge turned upside down, thus exposing the calibrated roller that comes in contact with the paper, or in this case the surface of the tablet. Because the calibrated roller's drum is made of plastic, it will slip heavily when in contact with the vinyl protective sheet that covers the surface of the tablet. To solve that problem, first, pry off the drum with a screwdriver wedged between the housing and one tip of the axle. Second, wrap wide rubber bands with a diameter slightly narrower than the drum's around each of the drum's edges. Third, snap the "axle" back inside the housing and watch the difference in performance.

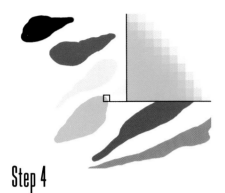

Step 4

Now that we've made some "blobs" of digital paint on screen, it is time to look at them closer. On the screen, increase the magnification (zoom in) and note how the image becomes a mosaic of little squares. These are the pixels. Each pixel has a shape—on most systems they're square; a location in the grid or map of pixels, commonly referred to as a bitmap; and only one color value. A pixel's size on the screen is a function of the resolution of that screen. Most monitors display 72 pixels per inch (ppi) at a zoom factor of 100 percent. How big they appear on printed page is a function of the printer's resolution.

tion of zeroes and ones, binary code. Large paintings can contain millions of pixels, yet all computer images can be broken down to this basic "paint-by-number" scheme.

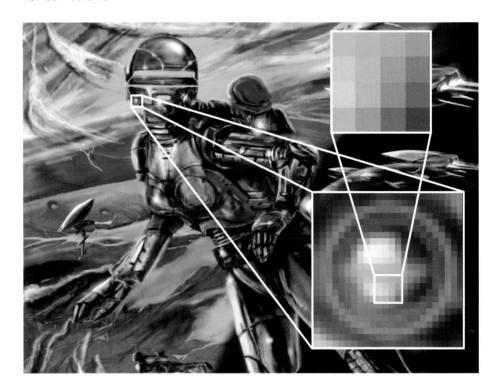

Step 5 ➹

While viewing the pixels at high magnification, grab one of the application's blend tools and drag them around while holding down the mouse button. The pixels aren't moving; the apparent movement is an illusion created when each pixel, whose location and size on the grid are fixed, changes color value. In fact, think of pixels as square holes in an egg crate waiting to be filled with colored eggs. The color of each pixel is a combina-

Step 6

How big is a pixel? Images on the monitor's screen are made up of a finite number of pixels. When such an image is viewed at higher magnification, the pixels appear to get bigger. Isn't it logical to assume that pixels have shape and size properties akin to objects in the analog world? Not at all, because pixels are interpretations of abstract elements, zeroes and ones. Talking about absolute measurements when describing pixels is impossible.

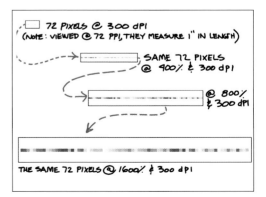

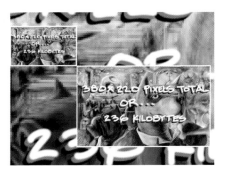

Step 7

Instead, think about the size of a pixel as a unit of data, or as the genetic code in human DNA, a mere molecule which, if translated into printed matter, would fill a library. The total number of pixels in a file determines how many kilobytes (KB) or megabytes (MB) it takes up on a hard drive. Note, then, that a magnified image is not bigger; it just looks that way.

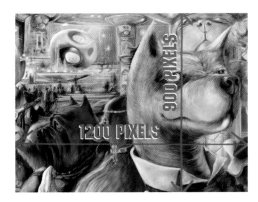

Step 8

Printing a painting isn't as easy as finishing it and clicking "OK." Ink dots and pixels are completely different. The science of converting pixels into ink dots—halftone or continuous tone—is constantly being perfected. In the meantime, note that most halftone outputs require the digital image resolution in pixels per inch (ppi) to be twice an imagesetter's line screen (lpi) ruling. For example, printing a 4" x 6" image using a 150-line screen ruling usually requires a digital file that contains 1200 x 1800 pixels which, when divided by 4 and 6 respectively, yields 300. That number is the digital file's (computer) image resolution in ppi. In the end, the quality of the output depends on the amount of pixels already available, and in this case, the more, the better.

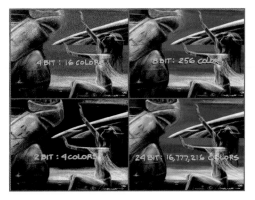

Step 9

Tonal resolution or bit depth is the information stored in a pixel that describes its color. Pixels occupy three-dimensional space, filling up a grid in both the horizontal and vertical directions; a third dimension constitutes the stack of information that determines the color of a pixel. As bit depth increases, so does the number of colors a pixel can display. The binary code uses zeroes and ones, or "yes" and "no" choices. At its most simple state, therefore, a pixel can either be on or off, white or black; at its most complex, a combination of white, red, green, and blue.

Step 10

In the digital color system, each pixel is a combination of red, green, and blue (RGB), or the additive primary color system. Why? Because the human eye contains three receptors that detect only red, green, and blue. In theory, all three put together make white light. In RGB mode, pixels look vibrant; however, when printed out on most inkjet, color laser, dye-sub or wax-transfer printers, some colors will look muted, because printers work with a cyan, magenta, yellow, and black (CMYK, K stands for black) system and not all of the colors can translate across systems. The subject of color management from monitor to print is beyond the scope of this book. Aside from reading, only experience will provide that firsthand feel for the problems that color printing will present.

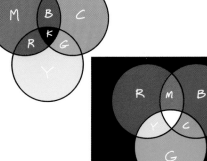

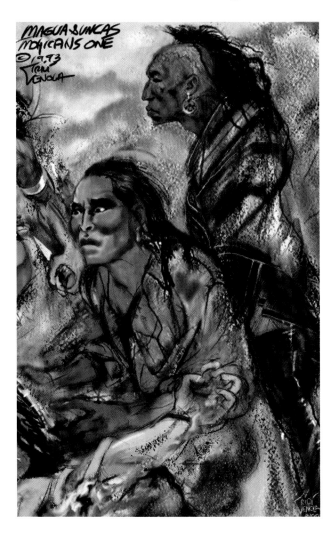

Magua/Uncas
Technique: Wet-on-Wet, Virtual Trace Paper
Trici Venola

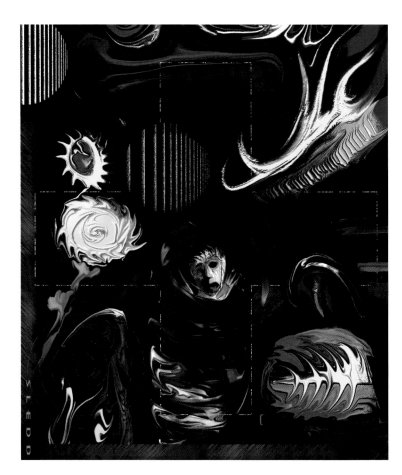

The Flowerpot
Technique: Wet-on-Wet, Virtual Masking
John Sledd

Angel See the Sun
Technique: Wet-on-Wet, Virtual Trace Paper,
Virtual Masking
Steve Campbell

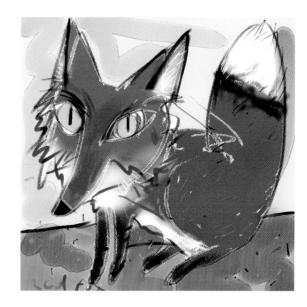

Red Fox
Technique: Wet-on-Wet, Virtual Trace Paper
Susan LeVan

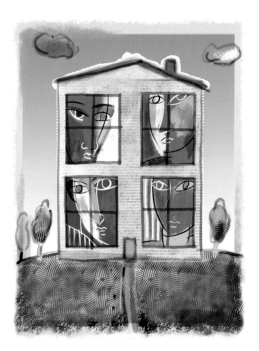

House on The Hill
Technique: Wet-on-Wet, Virtual Trace Paper
Susan LeVan

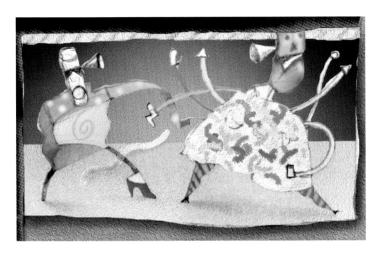

The Loud Argument
Technique: Wet-on-Wet, Virtual Trace Paper, Virtual Masking
Steve Campbell

Club Mutant
Technique: Wet-on-Wet, Virtual Trace Paper,
Digital Airbrush
Trici Venola

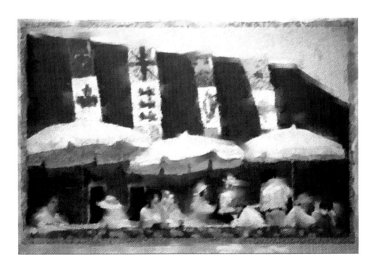

Cafe Scene & Flags
Technique: Wet-on-Wet, Painting Photographs, Digital Collage,
Painting 3D Images
Dewey Reid for Colossal Pictures

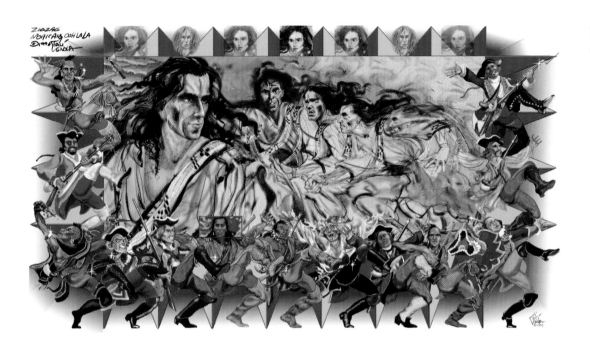

Zigzag Mohicans
Technique: Wet-on-Wet,
Virtual Trace Paper
Trici Venola

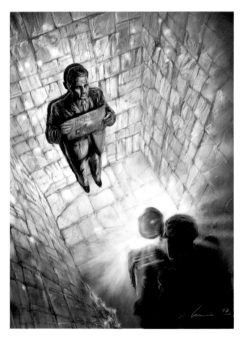

Mug Shot
Technique: Wet-on-Wet,
Virtual Masking, Virtual
Trace Paper
Mario Henri Chakkour

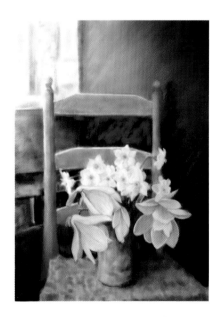

Chair with Tulip Tree Flowers
Technique: Wet-on-Wet, Virtual Trace Paper
Dennis Orlando

If only the Folks Back Home
Technique: Wet-on-Wet, Virtual Trace Paper,
Digital Airbrush
Trici Venola

Still Life with Pitcher and Apples
Technique: Wet-on-Wet
Dennis Orlando

Poetic Offering
Technique: Wet-on-Wet, Virtual Masking, Virtual Trace Paper,
Painting Words
Mario Henri Chakkour

Portrait of a Lady
Technique: Wet-on-Wet
Dewey Reid for Colossal Pictures

Night Visions 1
Technique: Wet-on-Wet, Virtual Masking
Karin Schminke

THE DIGITAL

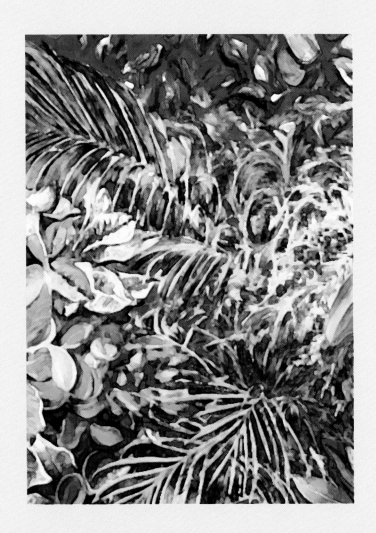

WET-ON-WET TECHNIQUE

Caribbean Watercolor *Dennis Orlando*

In the digital world, the wet-on-wet technique is the most basic form of painting with computers. The name is borrowed from the world of oil painting, both as an homage and a reminder that the processes and traditions of painting—wet or dry—live on.

Wet-on-wet is using brushes without masking and/or filters. It plays a role in every stage of digital painting. Used either as a warm-up session every day or as the prime method of painting, wet-on-wet provides the artist with the key to developing a unique style, and sets an artist onto the task of developing a unique brush stroke, the most difficult part of the digital painting process.

The following exercise, *Ring of Fire*, is an example of what happens during a typical drawing session, a painting that evolved from a simple warm-up.

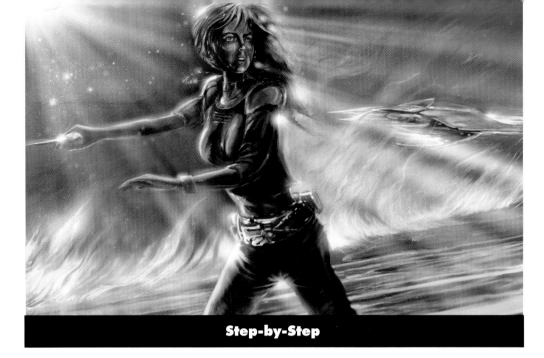

Step-by-Step

Ring of Fire

Software: Painter 2.0, X2, 3.0 or later, and PixelPaint Pro3

Hardware: Apple Macintosh Quadra 700, 20 MB RAM, 230 MB hard drive, Sony 16-inch monitor, Apple 13-inch monitor for palettes, 24-bit color, Wacom ArtZ Tablet (8.5" x 6")

Image Size: Initial sketch is 640 x 480 pixels. When massing color, image is scaled up to 1200 x 900 pixels. Toward substantial completion image is scaled up to its final size of 1800 x 1350 pixels.

Ring of Fire uses Fractal Design's Painter 3.0 and Pixel Resources' Pixel Paint Pro3. The main tools in Painter:

- Sharp Chalk for rough initial sketching and composition.

- Soft Charcoal for developmental sketching and rough massing of colors.
- Just Add Water for blending colors, washes, forming definition and atmosphere.
- Total Oil Brush for elaboration, and fine details.
- Airbrush for soft color build-up, glazing, elaboration, and fine details.
- Distorto for character and effect
- Pixel Dust for stipple effect.

The main tools in PixelPaint:

- Airbrush for developmental sketching and rough massing of colors, color build-up, glazing, elaboration and fine details.
- Finger for blending colors, washes, form definition and atmosphere.
- Waterdrop for subtle blending.

Setup

In Painter, create a new document by choosing File: New. Once the picture dialogue box appears, select an image area that is 640 x 480 pixels. For some, that size might be just about what the computer can handle before the brushes become sluggish. Next, select a color other than white after clicking the Paper Color rectangle. Select the chalk brush.

Brush tracking can be set by drawing with a lot of pressure and speed (Appendix B). Next, grab the chalk. Choose the Medium Tip profile and set the size you're comfortable sketching with by eye, using both Size and ±Size sliders. The black inner circle shows the minimum, and the gray outer circle shows the maximum. For most uses, set the inner circle's radius to half that of the outer circle's. In this case I set the upper slider to 13.6 and the lower to 1.47. To change the tip size from then on, simply move the upper slider left or right and watch how the ratio of the outer to inner circle radius stays the same. The chalk reacts with the texture of the paper. To harden the chalk and add more paper texture use Window: Controls: Brush and move the Grain Slider to the left.

Step 1

Relax and draw rhythmically. The key to a successful painting involving a figure in motion is capturing the essence of a gesture. Successful gesture drawing comes from a lot of observation, careful figure studies, and a love of movement. Movement is so natural that the mind can see the slightest mistakes. Do not linger too long in one place on the page. Try to make pen strokes come out in quick, fluid, subconscious bursts in order to make them look natural. If a burst does not look promising, get rid of it.

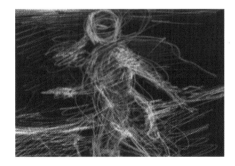

Step 2

By using a softer tool—charcoal—the original sketch will not be overwhelmed during this next step: The

additional search for formal, tonal qualities. Charcoal also reacts with the paper texture, and thus makes it visible. Use a sculptor's approach at this stage. Imagine caressing the form with the pen by varying the pressure on the tablet. Study the weight distribution. In fact, learn to keep that pen in constant motion. Let the pen explore every part of the tablet.

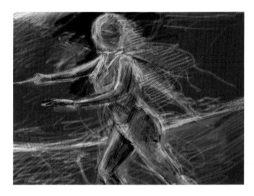

Step 3

The Water Brush is used to go over the charcoal. Note how blending effectively maximizes the illusion of depth. Blend a little more, mix the colors, and look for pleasing tones. Adjust them by adding charcoal and then repeat. Work on the composition as well. When the figure seems to be in a "ready to fight" gesture, quickly sketch the suggestion of a facial expression at this point, whether it's anger, fear, surprise, or a mixture of them all. Pay attention to the direction in which the figure is looking. This, along with the dark mass around her upper body, adds to the tension and creates a color contrast as well implying a mystery foe. Balance things out by creating the presence of a "friendly force" with a hint of light in the upper left corner.

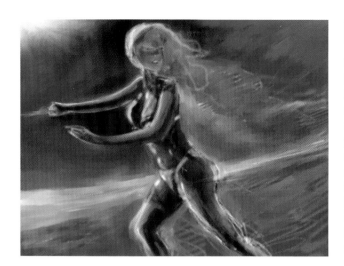

Step 4

Now that the rigorous sketching phase is over, resize the image to 1200 x 900 pixels, or larger if the machine can handle it. Next, blend the hues with the Water brush and create light and dark values. Use the Total Oil Brush, set very thin (Size all the way to the left with the ±Size slider three quarters to the right) to build the mass and shadows. Blend with Water then repeat. The Oil Brush/Water combination is the main brush technique used to render.

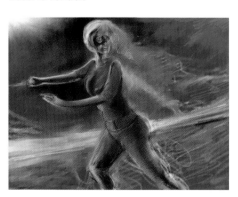

Step 5

While still using the Oil Brush/Water combination, make a closer study of light and shade—the background's seemingly two-dimensional splashes of color offer rich possibilities for adding depth. In this illustration, the background suggests that the environ ment is an enclosed space-a cave perhaps. It would be ideal to avoid casting certain shadows on her face, but that would not mirror real life. This example painting features complex combinations of secondary lights. Some are reflected, some are generated by a single source, casting defined shadows. It is important to produce a light and dark scheme that promotes balance.

Step 6 ➤

To achieve the effects illustrated in this project, more than one painting application is used. Save the image in PICT or TIFF format and open it in Pixel-PaintPro3. Here, PixelPaint's Airbrush tool—set to 50 percent flow and to 100 percent transparency—does a great job for sketching. In order to repeat the same effect as illustrated, rough in color with Airbrush, an opaque painting tool. Increase the flow and use

thinly, which replicates the Total Oil Brush in Painter. Work on the face next with the Finger tool, gently blending the shadows with a combination of circular and curvilinear movement. Then, follow with the Waterdrop tool. If the hues get washed from over-blending, then reapply some color with the Airbrush and repeat. Use the Airbrush's flow slider to increase or decrease pigment intensity. In the cheeks, unnecessary color is shaved using the Eyedropper tool to pick up color from the canvas, applied over the unwanted "color noise." Simply reduce the nib size and draw with the airbrush—alternating between colors—until the required result is achieved. Shadows and highlights are then applied with the Airbrush followed by a gentle smoothing with the Waterdrop tool. The belt buckle is a good example of the process: On the far right, note the scribbling with the thin Airbrush of an indication of a compartment. These lines were blended, and subtle strokes of white were added.

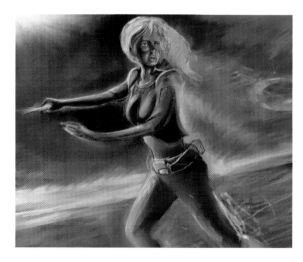

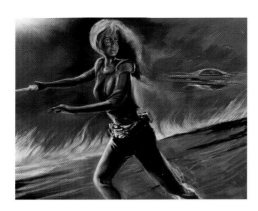

Step 7

When fleshing out details, a good place to start is to consider wrinkles in clothing. Remember, they follow the flow and motion of the body parts. The best way to visualize wrinkles is to imagine the compression and tension forces as arrows emanating or converging toward anchor points.

As with canvas, the hardest thing to do is to imagine the flat monitor screen as having depth. As an aid, always follow imaginary curves when blending, thus using circular paths. The spaceship is begun at this point with quick sketch marks. Some horizontal aquamarine lines are applied to complement the warm hues. Introduce more yellow in the "conflict zone," which suggests a band of fire. A little turquoise, however, cools down the hues here and in the figure as well.

Step 8

The bright spot in the upper left corner (made with PixelPaint's Airbrush blended with the Waterdrop tool) adds to the illusion of fragmented light. Note the band of fire. On the left side of the figure it bends with the wind, and on the right side, it breaks up. This adds to the illusion that the spacecraft—still in progress—is ready to land. Add depth and tension here by bringing up the foreground with bold, dark shadows on the inclined plane right behind the figure. The spacecraft, on the other hand, is so far a series of overlapping horizontal airbrush strokes. Position the pen in the middle of the space mass, start a back-and-forth motion with a good amount of pen pressure, then ease off the pen while lengthening the line. Repeat with other colors. Apply some curvilinear strokes as well. Blend with the combination Finger tool and Waterdrop tool. Add gentle, wide strokes of color with the Airbrush, lowering the flow to add atmosphere. Then bring the nib size down and add bright-colored lights on and around the belt.

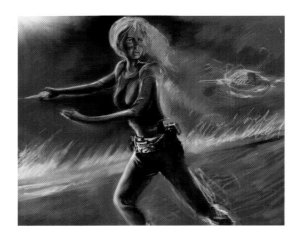

Saving Files

As a precaution, and because artists seldom interrupt the creative flow long enough to back up their work on an archive in the middle of a session, always use the Save As command versus Save. For example, when painting, Save As "Version One," after a little while, then Save As "Version Two" ten minutes later, then alternative back and forth between the two every so often, or more importantly, if an especially good effect is achieved while painting. This way if the computer bombs in the middle of the saving operation, you would still have a backup on the hard drive. Remember, when you Save you essentially erase the last version.

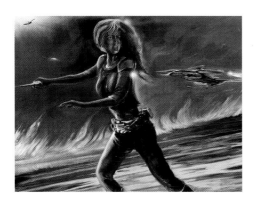

Step 9

Increase PixelPaint's Airbrush flow, select a bright aquamarine color then apply broad, generous strokes to make the river "flow." Save the image in TIFF format, quit PixelPaint and open it in Painter. Setting Total Oil Brush very thinly, use it like a felt tip. Winglets on the spaceship are rendered by filling in the color then blending with a little water. Repeat with the thinly set Total Oil Brush. Then, while gently pressing down the pen, airbrush a red glaze and then some yellow. Then apply generous black shadows under the ribs, and adorn with color points of light. Top off with gentle puffs of the airbrush. Remember, place the pen over the spot, then follow with a jiggle. If the painting is bigger, use a circular motion. Next, using the Total Oil Brush and dark crimson pigment, shave off some of the left forearm by freehand sketching. Smooth with the Water tool. To refine the smoothing action of the Water tool (covered in more depth in Appendix B) access the Window: Controls: Brush palette and move the Opacity slider to the left. Learning to work the slider by feel will allow you

to achieve the greatest range of smoothness. Add white highlights to the arms and hand with the airbrush. Note the blending of the highlights with the softer Water tool on the left arm.

Step 10

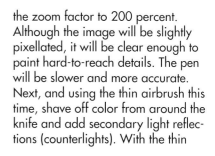

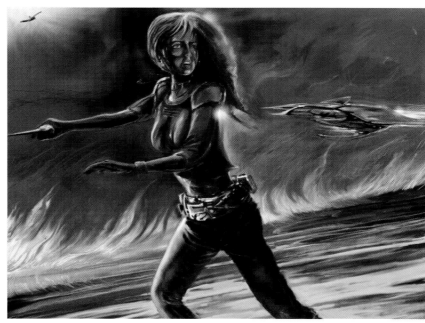

Blend the facial surfaces well, but gently, with the Water tool set at 20 percent opacity, until there are no clear boundary lines between highlights and shadows. To paint the river, set the airbrush to a comfortable nib size, and Draw freehand. If drawing becomes difficult in small areas, then the pen is traveling too fast. To paint small details without scaling up the image, which increases the file size and slow down the system, increase

the zoom factor to 200 percent. Although the image will be slightly pixellated, it will be clear enough to paint hard-to-reach details. The pen will be slower and more accurate. Next, and using the thin airbrush this time, shave off color from around the knife and add secondary light reflections (counterlights). With the thin

Total Oil Brush and with gold color, rub in the rectangular mass—a silhouette—of a bracelet. Then gently add thin strokes of crimson, then some darker reds. Blend with water. Again, if the area in question is too small to allow precise pen action, zoom in with the Magnification tool, work, then zoom out. The necklace is a perfect example of how a very thin Oil Brush can be applied with surgical precision.

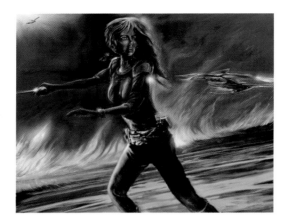

Step 11

Next, apply strokes to the hair as if using a regular paint brush, creating an effect similar to a thick oil spill. This effect is achieved by selecting the Distorto tool and setting the slider to 100 percent on the Controls: Brush palette. To really drag the color around, set the upper brush slider (Size) to full left and the lower one (+Size) to full right and use the Medium or Pointed profile. This creates strokes that range from hairline to thick. The Water tool is used to refine the hot spots in the upper-left-hand corner and above a few of the flames by dragging from the center out. Note the thin reflective sparkles, done in freehand mode using the "rolling ruler" outlined in Section One.

Some glow is added to the fire with the Airbrush.

Step 12

Tie it all together by applying stars with the Pens: Pixel Dust tool. Just check One Pixel in the Dab Types in Window: Brush Controls: Size, and experiment with different dot spacing by varying the Size slider. Vary the brightness of the hue to create depth. Airbrush white pigment over stars to create glare spots and then add some sparkles, or vary the sequence and see which is better. Save a scratch copy to do all this experimentation, lest you do irreversible damage. With the Rolling Edge, create radiating lines using the Airbrush from one vanishing point. Be patient. Some lines will stop short of the body and pick up afterwards.

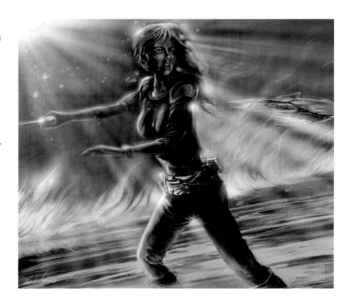

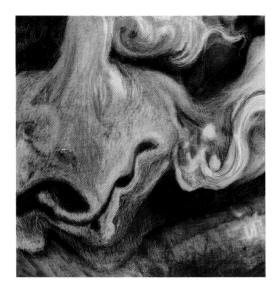

Upper View
Technique: Wet-on-Wet
Jan Ruby-Baird

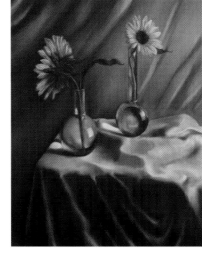

Eastern Light Sunflowers
Technique: Wet-on-Wet
Dennis Orlando

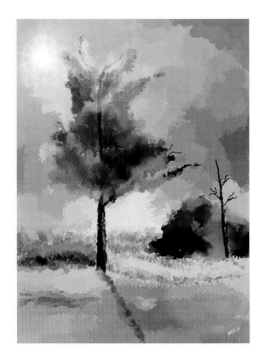

Autumn Tree
Technique: Wet-on-Wet
Stacy A. Hopkins

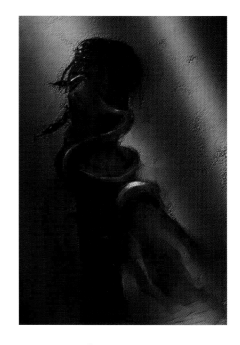

Woman with Serpents
Technique: Wet-on-Wet
Dewey Reid for Colossal Pictures

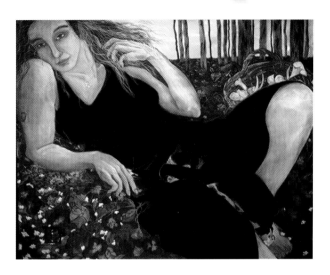

The Clearing
Technique: Wet-on-Wet
Debi Lee Mandel

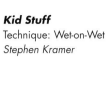

Kid Stuff
Technique: Wet-on-Wet
Stephen Kramer

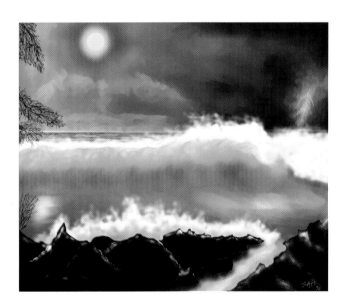

Storm
Technique: Wet-on-Wet
Stacy A. Hopkins

Cathy with Flowers
Technique: Painting
Photographs, Wet-on-Wet
Philip Howe

On the Farm
Technique: Wet-on-Wet, Virtual Trace Paper
Jan Ruby-Baird

Chimp
Technique: Wet-on-Wet
Jonathan Krop

Eagle
Technique: Wet-on-Wet
Stacy A. Hopkins

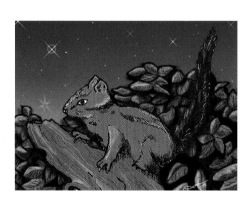

Chipmunk
Technique: Wet-on-Wet
Jonathan Krop

Yak
Technique: Wet-on-Wet
Dewey Reid for Colossal Pictures

Lush Stream
Technique: Wet-on-Wet
John Derry

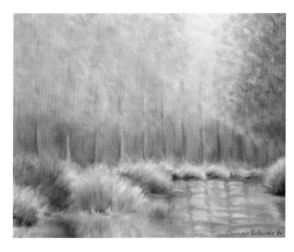

Bend in the Epte River
Technique: Wet-on-Wet
Dennis Orlando

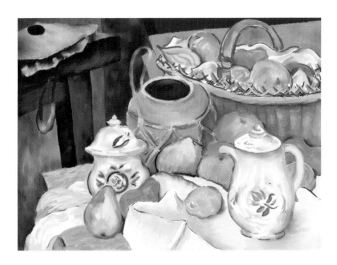

Still Life with Fruit Basket
Technique: Wet-on-Wet
Dennis Orlando

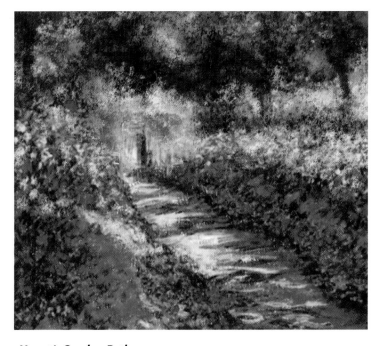

Monet's Garden Path
Technique: Wet-on-Wet
Dennis Orlando

DIGITAL

MASKING

Gail *Jan Ruby-Baird*

The next exercise, *Surf's Pup*, is an example of how masking can be used in combination with the wet-on-wet technique to generate crisper edges while preserving the integrity of the original sketch. In traditional pre-press operations, masks are used to combine separate images onto one piece of film; digitally speaking, masks can be used to prevent bitmaps from being painted over accidentally.

There are many ways to use mask materials, whether they are made of paper, vellum, frisket, acetate, or binary codes. One thing to remember is that masks are flat and that they—at the outset—define shapes, not form. The illusion of form is up to the artist, whether creating stylized, abstract, or realistic art.

Besides brushes, a traditional artist's studio usually has precision drawing tools that aid in the painting process, such as knives, templates, rulers, and straightedges. In the digital studio there are *selection tools* that can be rectangular, oval, freehand, Bézier, or automatic. Selection tools can be used to select a number of pixels and surround them with a "selection path", usually shown as black-and-white dashed lines—called *marching ants* in computer slang—or a "selection marquee". When a selection path is closed upon itself, the area outlined is called a Selection. In software documentation, Paths and Selections are often used interchangeably, although technically a path is merely the outline of the selection. Each software has a unique way of managing selections in one form or the other, although they might use a different nomenclature and a different approach.

All digital masks are born when the artist uses a selection tool. Once a selection is made, the artist may choose to paint within that boundary or outside of it. Just remember that, in general, once the cursor clicks outside of the boundary, the marching ants disappear along with all the hard work that went into creating them, so it's important to save them for later use. Floating selections literally are clippings that can vary in opacity and can be arranged at will.

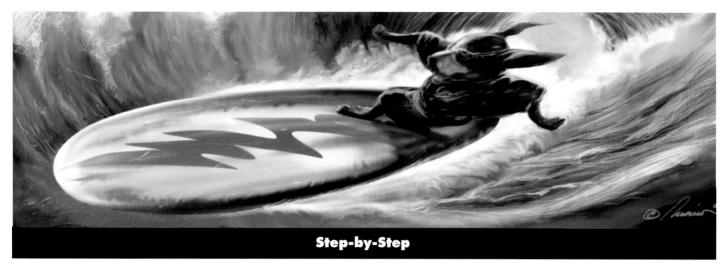

Surf's Pup

Software: Painter 2.0, 2.0 X2, 3.0 or later, and Adobe Illustrator if using Painter 2.0 and 2.0 X2 for creating Bézier curves

Hardware: Apple Macintosh Quadra 700, 20 MB RAM, 230 MB hard drive, Sony 16-inch monitor, Apple 13-inch monitor for palettes, 24-bit color, Wacom ArtZ Tablet (8.5" x 6")

Image Size: Initial sketch is done at 640 x 186 pixels. Image is then scaled up to 1400 x 407 pixels, before creating the friskets.

The brushes used in Painter include:

- Scratchboard (Pens: Scratchboard) for sketching
- Airbrush (Airbrush: Fat Stroke) for soft color build-up, glazing, elaboration, and fine details.
- Water (Water: Just Add Water) for blending colors, washes, form definition, and atmosphere.
- Total Oil Brush (Liquid: Total Oil Brush) for elaboration and fine details.
- Distorto (Liquid: Distorto) for character and effect

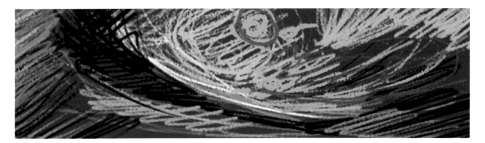

Masks and Friskets

"Frisket" and "Mask" mean the same thing. In digital terms, they make up the invisible 8-bit paint layer which can achieve 256 levels of opacity. Think of this layer as literally "hovering" on top of the actual painting. When activated, in part or as a whole by means of marching ants or selection marquees, they protect selected pixels from being altered. Masks and friskets are stencils you "carve" with Selections.

"Selections", created by selection tools, are further divided into "paths" and "curves" depending on whether they were created with freehand tools or Bézier tools.

Paths can also become the boundaries of masks. Once a selection is converted to a mask, it can be saved in a separate file, or, if in Photoshop, to an alpha channel. One advantage of digital masks over traditional masks is that the former can vary in opacity because they have a bit depth of eight. Masks, therefore, can display 256 levels of gray. These masks can be feathered, which means they can display shades of gray at the perimeter, while the rest of the mask is at full saturation. In lay terms, the result is a soft edge.

Step 1

To create the sketch, first imagine being a camera under a wave as a surfboard is about to rush by. Draw the first ellipse in red Chalk with an elliptical movement of the arm, not the hand, and while in rotation "carve" the pen into the tablet. The first stroke is the most important. Next, using blue Chalk and a broad, generous arm movement (back and forth like a pendulum,) sketch the concave part of the wave directly under the board. Next, sketch the left side of the wave. Now, with black and white, work in the contrasts. Draw an indication of a surfer; again, focus on rhythm during this step and not detail.

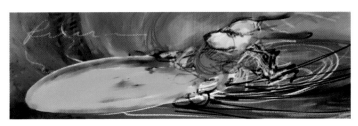

Step 2

The first sketch of *Surf's Pup* had a lot of potential, but because it was commissioned for an Internet home page it presented some technical problems. The surfboard should be drawn as

large as is possible without compromising the motion that the first sketch implies. To replicate this image, therefore, rough in some color with the Charcoal green for the surfboard, red and yellow for the pup. Mix with Water. Add some Prussian blue to block out the dark areas of shadows. Using white Chalk, apply thin strokes to suggest the rushing board's wake.

Step 3

Blend the Charcoal with Just Add Water to create waves. Don't worry if the pen falls outside the page while blending. Even if the image is not complete, the viewer's eye will automatically connect the dots. The image must be drawn with complete and fluid motion. If the pen keeps hitting the scroll bar, just choose Windows: Full Screen Toggle. Don't worry if the cursor draws over

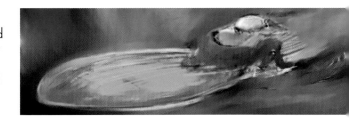

the many Palettes and Windows; it won't affect them unless the pen lifts off the tablet surface and touches down again over one of the Windows. In any case, use Window: Hide Palettes to hide the tools. As long as the stylus is ever so lightly touching the surface, anything drawn can be undone with the Undo command.

the Water tool's Opacity control to blend gently, add counterlights, and blend some more. Because there is no drying time involved, the process does not need to be linear. Drawing an outline with white and then blue Chalk will help define the edge of the surfboard for cutting the mask later. Remember to increase the screen magnification to gain more control when drawing freehand, as in Section two.

ing the nib off the tablet. Watch the appearance of a tiny rectangle, called a "selection point." Now move the cursor to the left of the rectangle and down. The cursor is now on the tip of the surfboard. Press-drag the cursor down: a Bézier curve is born! Repeat the steps above to generate subsequent curves around the surfboard's outline until the cursor connects with the first selection point. Note: Every time the cursor is relocated and the nib is pressed down and dragged, a new handle will appear. Handles are the tangents of the corresponding curve, and it will take experimentation to get used to how they stretch and drag. Once the curve around the surfboard is drawn it will appear as a series of icons in the Objects: Paths list. The red in the image is added to help visualize the path as it will become a mask. Using the same method, draw a path around the dog.

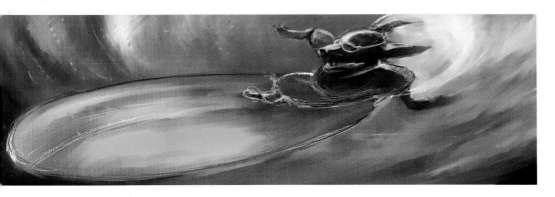

Step 4

Introduce green, orange, and red hues with the Charcoal tool at full value in the surfboard to complement the values and tints of blue in the background, ranging from light to dark. Mass the green in the left two-thirds of the surfboard, the orange in the right. Note the orange is actually a mixture of two colors: yellow ochre (or close to it) and red. Apply aquamarine on the right trailing edge of the board. Blend the areas with Just Add Water (Section 2). Paint the dog using the wet on wet; that includes using the Total Oil Brush set very thinly to enrich the details. Add contrast—highlights and dark values—to the dog's head by taking advantage of

Step 5

Now we're ready to cut masks. First, choose the Outline Selection tool (pen nib icon) from the Tools palette. This turns the Controls palette into the controls: Outline Selection palette. Select Bézier Curves under Draw Style and draw a precisely fit curve around the surfboard. Choose a point along the intended curve on the upper left of the surfboard and point the cursor (x-shaped) at it, press the nib down (it turns into an arrow) and drag it to the left. Release by lift-

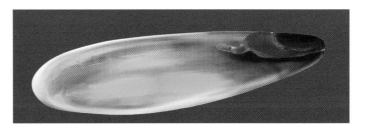

🎩 Of Mice and When...

Should the mouse be put to pasture once the tablet is plugged into a virtual studio's arsenal of tools? Not at all. First, what if the pen acts up or there is a bug in the tablet's software driver? You need a back-up system. Second, the mouse or even a puck is a better tool to use when using vector-based software such as Adobe Illustrator. Also: Never disconnect a mouse, or anything for that matter, when the system is on: you run a good risk of blowing it up.

Sometimes, because of a monitor's size limitations, cutting the path all at once may not be possible. Lifting the pressure off the nib midway will connect the start-up point and the last point of contact and generate a closed path. To resolve this difficulty in Painter, create the overall path as a series of smaller, interconnected paths to slow down and increase the precision of the Outline Selection Tool. If the cursor moves too fast relative to the hand movement, a good trick is to increase the screen magnification while working. Also, to make things even more convenient, the space bar alone can turn the cursor into the Hand tool or the Grabber.

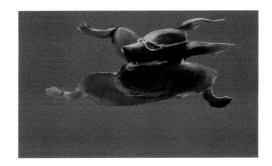

Step 6

Draw the path around the dog in freehand mode. To do so, choose Freehand in Controls: Outline Selection. Drawing freehand is simpler, but requires a steady hand. Point the cursor, press down on the nib—not too much since this is not a pressure sensitive operation—and imagining the pen as a knife, "cut" the outline of the dog out by tracing around it. Stick with the pen; unlike creating the Bézier curve above, the mouse here is useless.

Step 7 ↗

Creating paths is the first step toward making masks. Before doing that, some minor preventive measures are

recommended so that work is not lost by accident later in the process. First, it is important to name each path and record its coordinates. Study and understand what the Objects: Path List is saying. This brief review will help. First, note that two items have been indicated so far: a *curve* and a *path*. To understand what these icons really mean, in addition to reading the manual, double-click on the first and a new window will open, the Path Attributes window. Enter an appropriate name like "surfboard" followed by the string of numbers that appear in the bottom dialogue boxes entitled Top and Left. These are the coordinates of the surfboard curve. The name will look something like this: surfboard 140.997 77.999. Why the stream of numbers? If the artist moves the selection by mistake, it becomes extremely difficult to reposition the marching ants; if the coordinates are recorded, the computer's processor can replace them for the artist, perfectly, over and over again. The rest of the information in the Path Attributes box, serves as a quick course in the plethora of options available for converting paths into active, inactive, Bézier, and the like.

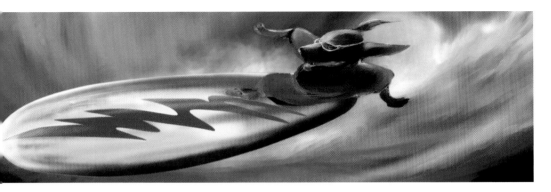

Step 8

Another path is cut around the surfboard's thunderbolt (illustrated here in a rendered stage). That's it: three paths in total, two of which are editable curves, all named appropriately. Now it is time to convert them into selections, which are then converted into masks (a term interchangeable with friskets in the context of this discussion) to protect the artwork. In Objects: Paths List, click on the thunderbolt's curve icon until the marching ants reappear. Using the bottom row in the Drawing and Visibility buttons, click on the middle button (with a red patch over the color) and watch the effect. The whole image is now masked except the thunderbolt. Apply some color within. Is there pixellation (jagged edges) at the perimeter? Then feather (soften or lift) the mask. First, make sure both the handles and the marquee are active by clicking the selection directly or by highlighting it in the Objects: Path List.

Next, click on the middle Drawing and Visibility button in either the Objects: Path List or Controls: Path Adjuster to activate the colored mask again. With the handles active, use the Feather slider to soften the edge.

Step 9

Each mask can be feathered differently than its neighbors. To reverse the mask and work on the area outside of

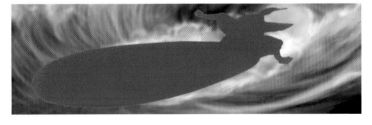

it, use the middle button in the Drawing and Visibility buttons. Remember that anytime two or more active marquees touch, like the thunderbolt and the surfboard or if one is enclosed within the other, the resulting mask will include the whole group. Painter's "smooth" button is used primarily when importing EPS files and opening them as friskets (see Section 5).

The rest is easy. Paint as usual, except note how the edge of the surfboard has a cleaner look to it. In the meantime, the surfboard, dog, and thunderbolt each were rendered separately. Reverse the masks and develop the wave further by applying the Airbrush. Use many hues of blue and green and mix with white.

Blend with water by using Water: Just Add Water. Rub gently and this time learn to play with the opacity control in Controls: Brushes. This changes the strength of the blending power of the water tool. Set at 20 percent to blend very gently.

Step 10

Next, to refine the wave, apply the thinly set Total Oil Brush to build up layers of froth and spray. Be patient; draw every vein! Follow with strokes

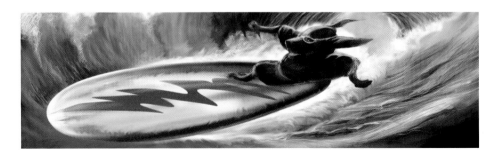

of the Distorto tool (Size 10.0 ±1.45, medium profile) in quick, snake-like passes, as if signing an autograph. Note also that Distorto darkens the hues if applied further in the same spot and generates an "oily" look, as well as a good level of saturation. Note how Distorto creates an effective illusion of mirrored light that suggests smooth surfaces. Add highlights to the surfboard and the water with some white with Airbrush.

the Total Oil Brush. Highlights follow. The tongue and ears should be drawn to suggest air is flowing around them, suspending them. Note the light patch on the dog's face, the trademark of a beagle. The image is a little too perfect. The hardest part of creating this painting is yet to come: finding a good balance between the orderly, masked technique and the freedom of wet-on-wet.

Step 12

First, deactivate the masks. Next, grab the thinly set Total Oil Brush and go over the surfboard with streaks of white to suggest water spray. Sign the painting using the Scratch tool. Note: To clear a mask, use the button in the Objects: Path List and press. Clear once the path is selected. When using Delete, however, make sure to only select the Pointer tool, or the pixels within the boundary will be erased and the background color will show.

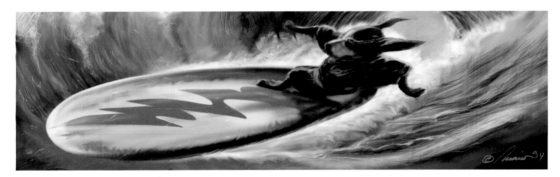

Step 11

Flesh out the swimsuit using wet-on-wet: rough in the colors with Charcoal, blend with Water, repeat. Render the details using the thinly set Total Oil Brush. To suggest wetness squiggle—with fast, light strokes—the Distorto brush over the masses built with

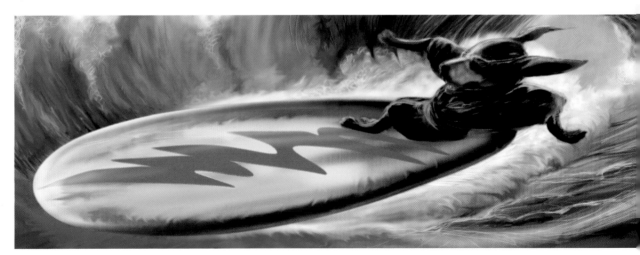

Island Driftwood
Technique: Wet-on-Wet, Virtual Trace Paper
Dennis Orlando

Willow Pond
Technique: Wet-on-Wet, Virtual Trace Paper
Dennis Orlando

Canoe Trip at Cedar Waters
Technique: Wet-on-Wet, Virtual Trace Paper
Dennis Orlando

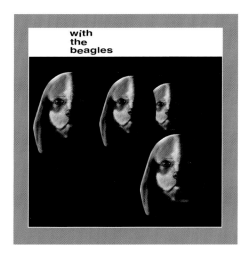

With the Beagles
Technique: Wet-on-Wet, Virtual Masking,
Virtual Trace Paper, Painting Words
Mario Henri Chakkour

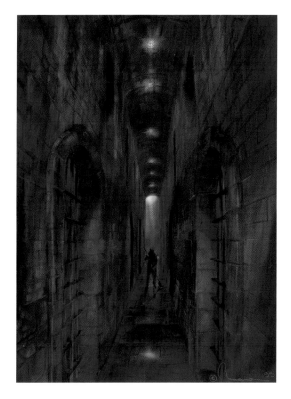

Prison Tunnel
Technique: Wet-on-Wet, Virtual
Masking, Virtual Trace Paper
Mario Henri Chakkour

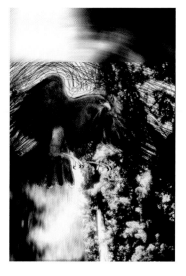

RedHawk
Technique: Wet-on-Wet,
Virtual Masking
Karin Schminke

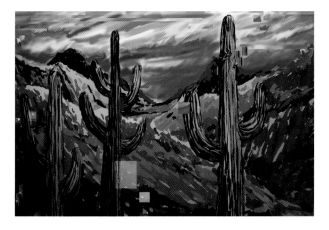

Cactus
Technique: Wet-on-Wet, Virtual Trace Paper
Kathleen Blavatt

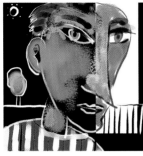
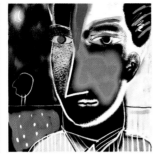
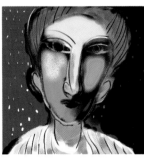
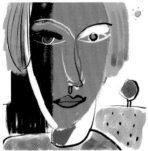

Four Faces
Technique: Wet-on-Wet, Virtual Trace Paper
Susan LeVan

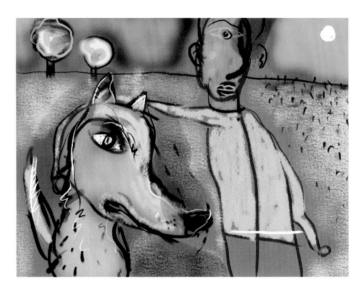

A Boy and His Grey Dog
Technique: Wet-on-Wet, Virtual Trace Paper
Susan LeVan

The Agreement
Technique: Wet-on-Wet, Virtual Trace Paper
Susan LeVan

Seancé
Technique: Wet-on-Wet, Virtual Trace Paper, Virtual Masking, Painting Photographs
Steve Campbell

Womanhood
Technique: Wet-on-Wet, Virtual Trace Paper
Kathleen Blavatt

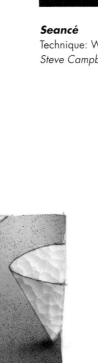

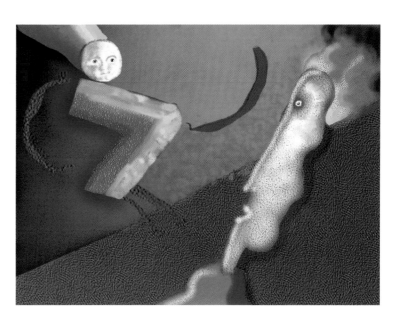

The Seven
Technique: Wet-on-Wet, Virtual Trace Paper, Virtual Masking
Steve Campbell

Go Little Pot Go
Technique: Wet-on-Wet, Virtual Trace Paper, Virtual Masking
Steve Campbell

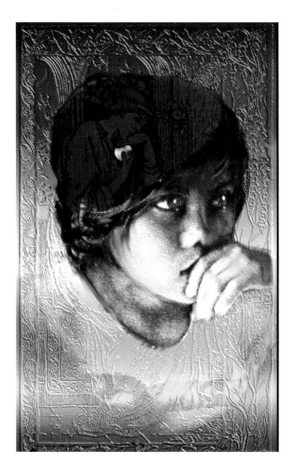

Oil Heart
Technique: Wet-on-Wet, Virtual Trace Paper, Virtual Masking
Steve Campbell

The Golden Apple
Technique: Painting Photographs, Digital Collage,
Virtual Masking
Dorothy Simpson Krause

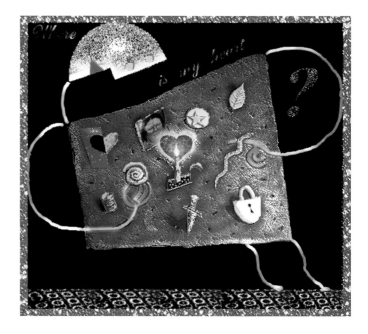

Where is My Heart
Technique: Wet-on-Wet, Virtual Trace Paper, Virtual Masking
Steve Campbell

Mission
Technique: Virtual Masking, Wet-on-Wet
John Sledd

Leaves of Bears
Technique: Wet-on-Wet, Virtual Masking, Virtual
Trace Paper
Mario Henri Chakkour

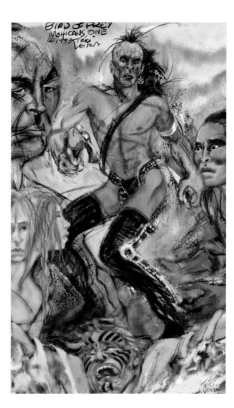

Bird of Prey
Technique: Wet-on-Wet, Virtual Trace Paper
Trici Venola

VIRTUAL

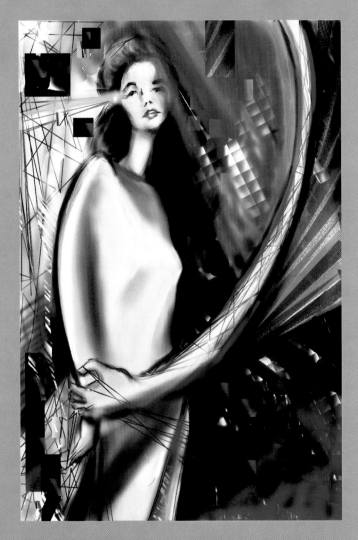

TRACE PAPER

Intwined *Kathleen Blavatt*

So far, the exercises have demonstrated how the digital medium can work in a dynamic creative process. What if, however, the nature of the work makes it hard to rely solely on the artist's on-the-fly reinterpretation of the original sketch?

Good sketches contain information that is both technically demanding and artistically evocative. Therefore, the hardest task an illustrator faces is maintaining the qualities of the original sketch. Ask anyone who has tried to read a sketch through the layers of pigment: Once paint covers the pencil lines, the artist has reinvented the sketch. In the non-digital world, tracing paper can be used to copy a sketch and preserve the original; this method can also be used with the digital canvas.

This section introduces several tools that mimic light tables, opaque projectors, tracing, and transfer paper. Since software environments vary, the methods of achieving virtual trace vary also. Please refer to Appendix C for more information.

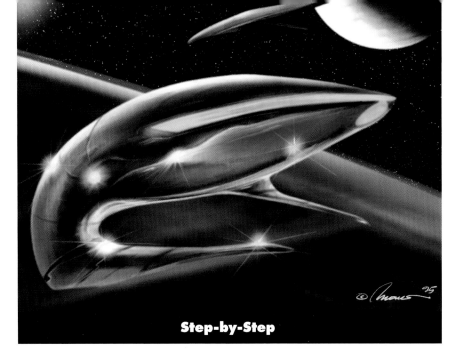

Step-by-Step

Space Ship

Software: Painter 2.0 X2, 3.0 or later, and Adobe Illustrator if using Painter 2.0 and 2.0 X2 for creating Bézier curves

Hardware: Apple Macintosh Quadra 700, 20 MB RAM, 230 MB hard drive, Sony 16-inch monitor, Apple 13-inch monitor for palettes, 24-bit color, Wacom ArtZ Tablet (8.5" x 6")

Image Size: Initial sketch is 640 x 480 pixels. Image is then scaled up to 1200 x 900 pixels before creating the trace and friskets.

The brushes used in Painter include:

- Scratchboard (Pens: Scratchboard) for trace-overs.
- Chalk (Chalks: Sharp Chalk) for rough initial sketching and composition.
- Charcoal (Charcoal: Soft Charcoal) for developmental sketching and rough massing of colors.
- Airbrush (Airbrush: Fat Stroke) for soft color build-up, glazing, elaboration, and fine details.
- Water (Water: Just Add Water) for blending colors, washes, form definition, and atmosphere.
- Total Oil Brush (Liquid: Total Oil Brush) for elaboration and fine details.
- Distorto (Liquid: Distorto) for character and effect.
- Pixel Dust (Pens: Pixel Dust) for stipple effect.

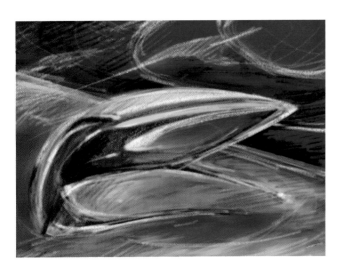

Step 1

Start with a quick wet-on-wet sketch at 640 x 480 pixels. In this case, a space ship is suggested in the foreground, a planet in the middle ground with some flying machines, and finally, some planets and stars in the background. Rescale the image to the desired size. (Canvas: Resize: Resize Image) to 1200 x 900 pixels. In Painter, place a sheet of virtual trace paper by selecting File: Clone. A duplicate image will appear—the clone of the original. Using the clone, choose Select All: Delete. Click the Tracing Paper icon off and on (or toggle, Command: T), to watch the original image appear and disappear. When appearing, it looks as if covered with tracing paper; when disappearing, it leaves behind a blank page the color of the background chosen for the original. Make it pure white (hue 0%, saturation 0%, value 100%) with Select All and the Fill bucket.

Step 2

For now, the clone looks white, but it's there, a virtual piece of tracing paper. Select the Pens: Scratchboard and choose black. Click on the Tracing Paper icon. Proceed with creating a freehand trace-over. Remember to draw at high magnification to gain more control over the pen. At this juncture, it's fine to brainstorm. Don't worry about making mistakes; simply choose white and erase, choose black and redraw.

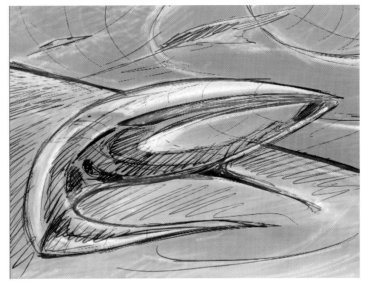

Step 3

Here, black wasn't the only color used; many colors can be, the important thing is to maintain contrast. Now save the image, noting that as long as the link between the clone and the

clone source is active, any new 1200 x 900 pixels file will be linked to the clone source. Press Control: Point-and-Click to sever the link between the clone and the clone source. Save the sketch as a separate file, calling it something appropriate such as "Ship Trace." Save the painting as work in progress.

Step 4

Now use the sketch as a guide to painting freehand. Open the sketch. Choose Edit: Mask: Auto Mask: Image Luminance. Select all, and click on the image with the Floating Selection tool (i.e., the "pointing finger") The image is now floating. Check Objects: Floater. It's there and aptly named something like "Floater One." In the same window, deselect Show Selection Marquee in the far bottom and locate the Image Mask Visibility buttons. While Floater One is active, click on the far upper right Image Mask Visibility button and leave the lower left button alone. Watch what happens: The background of the original image (Step 1) reappears. No problem. Deselect Floater One, select the Fill bucket again; and flood the page with pure white. Note that the sketch lines are floating magically over the page. Select Floater One again and, with the Fill bucket, flood the lines with light blue. Select the Floating Selection tool and reduce the opacity of the lines. Deselect Floater One; select a painting tool; and apply some colors on the white page under the floating lines. The sketch is now a floating wireframe, with no background noise to interfere with the

colors underneath. Save the floating sketch as a third file called "Wire Frame," making sure it is in RIFF format.

Step 5

To cut the masks, there are also a few options. The most simple one is to float the sketch on top of the painting, reduce its opacity, and use it as a guide. Or, an artist may open the original sketch, generate the masks there, and import them

to the final painting. This example follows the latter method, since the sketch is clear enough. Also, this image shows that the "weaving" of the path occurs at a higher magnification ratio. In fact, note the subdued image: This path is being constructed after floating the sketch on the same page, reducing its opacity, deselecting it, and working on the white background below. This way, the dark line will not compete with the thin path line.

Step 6

Now that the paths have been drawn, how does the artist import them into the

final image? This involves floating the elements. In Painter 3.0, never float an active path while another path is active; to deactivate a path, use Objects: Paths List (Section 3) and click on the path in question until it appears as a continuous line in the image. All the paths are shown in an inactive state. Float the windshield, for example, and then select Undo. Don't worry: The selection will not be erased; Undo will only get rid of the "halo" that is often created when floating a feathered mask.* Reselect the floating selection; name it; and record its coordinates in Objects: Floaters List using the same technique as with Objects: Paths List in Section Three. Deactivate the windshield path; activate the outline of the ship; float; select Undo; and repeat until all elements have been floated. In this case, there are five floating selections: two planets, two spaceships, and the windshield of the larger spaceship.

*Since the writing of this book, version 3.1 of Painter was released requiring the following update regarding floating selections. If using version 3.1 to get rid of the halos, follow this procedure: Make a scratch copy of the original painting; float the selection; note the coordinates of the floaters; copy floaters; paste floaters in scratch file. That will take care of the halo effect.

Step 7 ↘

Now copy and paste each floater in the painting; reposition them by entering the corresponding coordinates. To import all the floaters at once, group the floaters using the Group button in Objects: Floaters List, then treat the group as an individual floater by recording the coordinates of the group. Copy, paste, and reposition the group as shown above.

Now the painting is full of floating selections that are neither complete nor practical to use, unless the artist intends to airbrush each one individually. Drop all the floating selections. Then select Undo again. (if in Painter 3.1, simply discard floaters after selecting undo) This time, the dropped floating selections disappear. Check out Objects: Paths List in the final image; it contains five paths. The beauty of this technique is that the artist can feather and refloat. For now, stick with converting the paths into masks as outlined in Section Three. Also, to make the painting process even more convenient, copy and paste the floating selection in the saved RIFF, Wire Frame.

Redrawing the Image on the Screen

Sometimes the screen refreshes only part of the image, even parts of Palettes and Windows. If this happens, move Windows and Palettes around the screen atop the "dead" spots; this should remedy the problem.

There are no two ways about it: Keep blending with one-way strokes like planing a wooden surface until the desired effect is achieved. The dark areas—one of them suggests a jet intake hole—combine the Total Oil Brush (very thin) with Water for blending. Setting the Water tool at 100 percent and varying the pressure with the tablet creates the crater-like surface of the big planet. Rough-in some color to define the outline of the distant ship and planet.

Step 8

This stage returns to the wet-on-wet technique. For starters, regenerate masks and render each element clearly. Remember, there are no floating selections anymore, we dropped them in the last step. The ship could have been floated and rendered in a floated state, as well as the other elements, and that will be shown later. Why use one method over the other? Partly choice, partly system limitations and CPU speed. For the ship, the basic tools in the preceding sections were used. Note that the water tool set at a 20 percent opacity level is crucial to create the illusion of smooth metal.

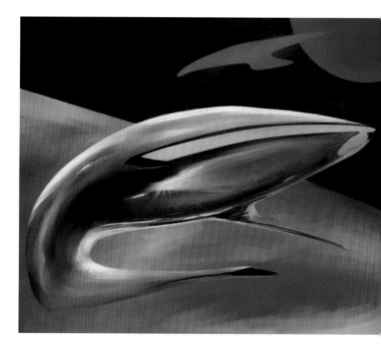

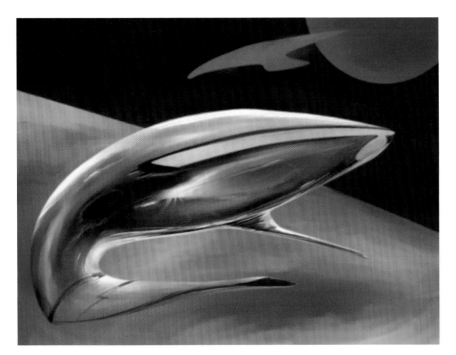

Step 10

Create the hot spot in the jet's intake hole by combining airbrushed yellow and lines radiated first with the Water tool, then with the Airbrush. The planet in the distance was created with a traditional, airbrushed look (Section Five) in mind. Note the sequence: White, yellow, burnt sienna, then black. Just as in Section Two's illustration, create the stars using the Pixel Dust tool again and choose white, which will apply dots of one pixel each. When the white stars are laid down, the background looks flat. Correct this by spraying the background with different hues of gray.

Step 9

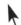

Study the edges: Is there enough feathering? In other words, will there be pixellation at the edges? This is where trial and error helps. More detail is applied with the Total Oil brush to suggest the intake hole, sections of the fuselage, and more detail around the windshield. Apply highlights. The dark tones around the bright windshield are applied freehand. Again, enlarge the magnification when painting; sometimes a light dash of airbrush is applied to enrich the tones. The solar flare in the middle is created with the Water tool, like the hot spots in Section Two.

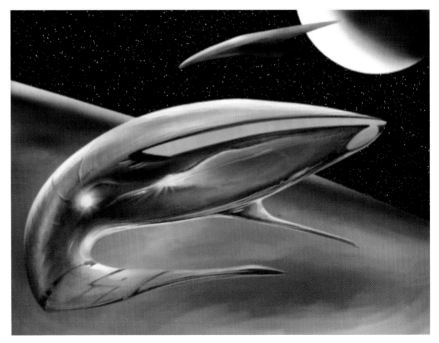

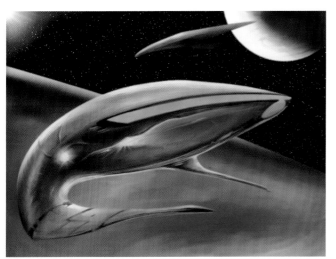

Step 11

With the Water tool, work some craters into the yellow planet. The Distorto tool, set very thin, is also helpful to drag some of the dark values. As for lighting, there are two bright suns: one reflected in the fuselage, and the other a large airbrushed disc with a hot center needs to be rendered. Once again, create a burst of white pixels using the Airbrush, followed by radiating lines with the Water tool, followed by an Airbrush overlay. To add the spherical glow, work the pen in a spiral movement, often starting outside the page, which may require the use of Windows: Screen Mode Toggle to reduce screen magnification. To create the disk, which is really only the illusion of a sphere with a dense center, place the stylus on the center; jiggle the pen to activate the pixels, orbit the center, then shift to a spiral movement. Control the pressure while rotating to avoid unwanted hot spots.

Step 12

Next, apply rich, dark shadows to intensify the glowing effect of the windshield. With the mask around the ship activated, spray on the wake trailing off the airfoils. To airbrush the planet behind the ship, turn the marching ants outlining the ship into a Negative selection by clicking on the Negative button in Objects: Path List. Activate the planet marquee. Click on the third upper and lower middle visibility buttons. Then paint the planet and the aurora. Highlight the planet marquee (the little handles will appear) either by pointing on it with the pointer or by clicking on its name in Objects: Path List. Next, click the Widen button. Enter "20" pixels. A new selection proportional to the planet's outline will be created; activate it. With the Airbrush, suggest an atmosphere around the planet. With a burst of airbrush, create the

sparkles reflecting from the ship's shiny surface. Then use the Total Oil Brush (Size 2.0, ± Size 1.85), the color white, and the Rolling Edge from Section One to create the radiating lines. Remember racing toy cars as a kid? First the car is first placed on the ground, the pressure is applied and the hand revs the car with a quick back and forth motion, and zoom! the car is released. The same motion applies to the stylus; the trick is to use both pressure and speed to control the size of the line.

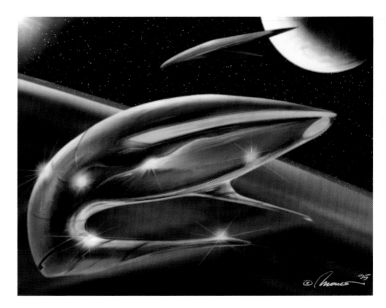

Bird Splash
Technique: Wet-on-Wet,
Virtual Trace Paper
Philip Howe

Wedding Cake
Technique: Wet-on-Wet,
Virtual Trace Paper
Kathleen Blavatt

Flowers in Light and Shadow
Technique: Wet-on-Wet, Virtual Trace Paper
Dennis Orlando

Danae
Technique: Wet-on-Wet, Virtual Trace Paper
Debi Lee Mandel

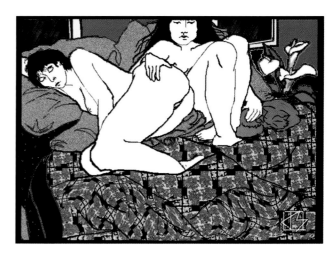

Nightwatch
Technique: Wet-on-Wet,
Virtual Trace Paper
Debi Lee Mandel

Lovers
Technique: Wet-on-Wet, Virtual Trace Paper
Kathleen Blavatt

Genesis One
Technique: Wet-on-Wet, Virtual Masking, Virtual Trace
Paper, Digital Airbrush
Mario Henri Chakkour

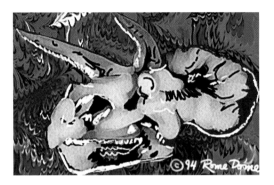

Triceratops Skull
Technique: Wet-on-Wet, Virtual Masking, Virtual Trace Paper
Romeo A. Esparrago, Jr.

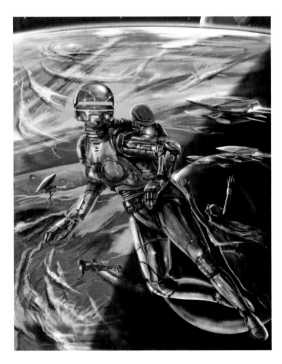

Free-Fall
Technique: Wet-on-Wet, Virtual Masking,
Virtual Trace Paper, Digital Airbrush
Mario Henri Chakkour

Street Lamp
Technique: Wet-on-Wet, Virtual Masking,
Virtual Trace Paper
Mario Henri Chakkour

Wendy
Technique: Wet-on-Wet,
Virtual Trace Paper
Kathleen Blavatt

Networking
Technique: Wet-on-Wet, Virtual Masking, Virtual
Trace Paper, Painting Photographs
Stephen Kramer

Water Resources
Technique: Wet-on-Wet,
Virtual Trace Paper
Ayse Ulay

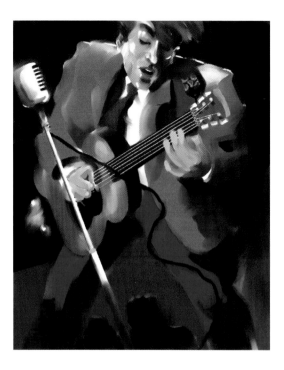

Guitar Player
Technique: Wet-on-Wet, Virtual
Masking, Virtual Trace Paper
Kerry Gavin

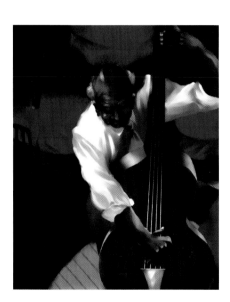

Solo Bassist
Technique: Wet-on-Wet, Virtual Masking,
Virtual Trace Paper
Kerry Gavin

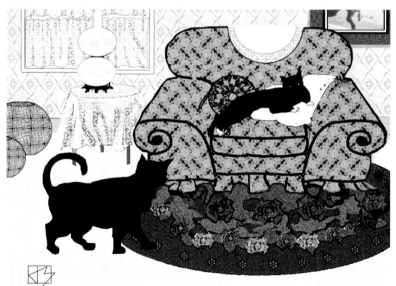

Territory
Technique: Wet-on-Wet, Virtual Trace Paper
Debi Lee Mandel

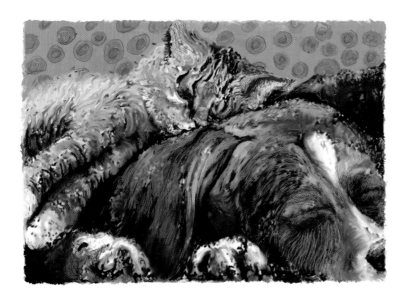

Georgia and Pablo at Peace
Technique: Wet-on-Wet, Virtual Trace Paper
Jan Ruby-Baird

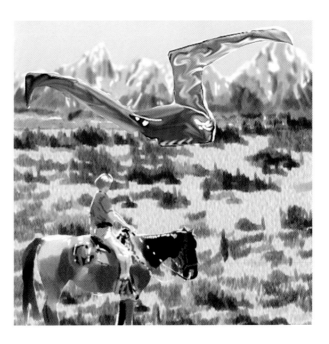

PM5 Cover
Technique: Wet-on-Wet, Virtual Trace Paper
Romeo A. Esparrago, Jr.

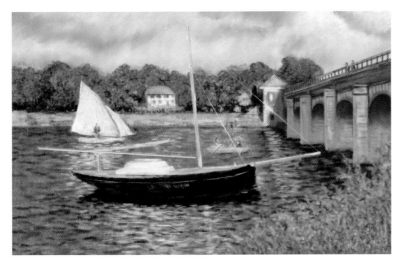

The Bridge at Argenteuil
Technique: Wet-on-Wet, Virtual Trace Paper
Dennis Orlando

DIGITAL

AIRBRUSH

Frajlupe *Corinne Whitaker*

So far, the digital Airbrush has been used as a secondary tool, to accentuate or attenuate colors, and not as a primary painting tool. This section builds upon techniques outlined in Chapters Two and Three; so far, the images were created by combining the digital wet-on-wet technique with the more refined look of masking using digital *friskets* (stencils), and other basics of using transfer paper. All in all, the base painting was the result of a lot of brushing-by-hand technique. By now, using the Airbrush should be second nature.

This step-by-step features the digital Airbrush as a primary painting tool: the focus is on body color, with less attention to wash, blending, or mixing. Fine-tuning will take place by using the Hand Brush often, because building a work with friskets alone can yield paintings that are static and uninteresting, or too perfect to be realistic.

The Airbrush, in general, offers a vast range of color possibilities, due to its ability to control transparency. Therefore, the color that is applied first will greatly determine whether the resulting tones are warm or cold. With real airbrushing, there is less flexibility regarding color sequence, while in the computer world of airbrushing it is completely different since there is no need to clean the Airbrush and mess with color jars, there is more time to experiment with different possibilities.

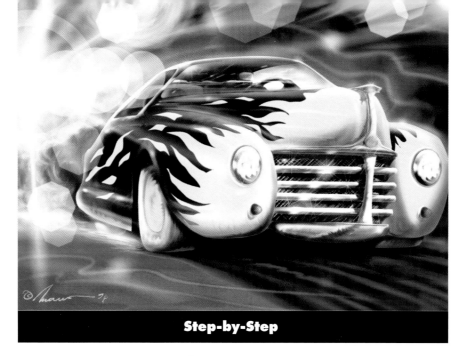

Step-by-Step

Hot Rod

Software: Painter 2.0, 2.0 X2, 3.0 or later, and Adobe Illustrator if using Painter 2.0 and 2.0 X2 for creating Bézier curves

Hardware: Apple Macintosh Quadra 700, 20 MB RAM, 230 MB hard drive, Sony 16-inch monitor, Apple 13-inch monitor for palettes, 24-bit color, Wacom ArtZ Tablet (8.5" x 6")

Image Size: Initial sketch is done at 700 x 525 pixels. Image is then scaled up to 1400 x 1050 pixels, before creating the friskets.

The brushes used in Painter include:

- Scratchboard (Pens: Scratchboard) for sketching
- Airbrush (Airbrush: Fat Stroke) for soft color build-up, glazing, elaboration, and fine details.
- Water (Water: Just Add Water) for blending colors, washes, form definition, and atmosphere.
- Total Oil Brush (Liquid: Total Oil Brush) for elaboration and fine details.
- Distorto (Liquid: Distorto) for character and effect.

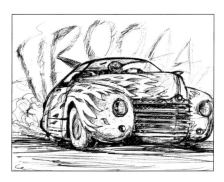

Step 1

Start with a sketch created with the Scratchboard tool in Painter. The sketch is done in real-time as a trace-over of a rough, low-resolution drawing scaled up to 1400 x 1050 pixels. This drawing features a hot rod with yellow flames on black ground. Leave the background alone for now.

Step 2

If version 3.0 of Painter—with its Bézier curve capabilities—is not available, import sketch as a PICT file into Adobe Illustrator and open it as a template. Draw the curved lines that will eventually become the outlines of the friskets: Some splines will overlap. In Illustrator, once all the outlines are

drawn, save the file in EPS format and import to a new page in Painter, using the Frisket palette's Library and Import EPS buttons. Choose black as the color of the page.

If Illustrator is not available, then the frisket can be carved freehand in Painter with the Frisket Knife tool. First, magnify the image for better control and to slow down the cursor. Build the frisket in small sections, as shown in Section 3.

Step 3

Once the friskets' outlines appear as marching ants, choose Select All, resize proportionally, and move on page using the Pointer tool. To resize a frisket proportionally to the original, grab a corner handle versus the side selection handle, and, while pressing the shift key, drag the pen to the

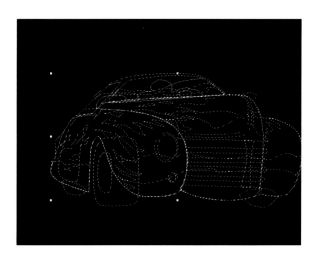

desired size. If importing as EPS, smooth and feather into the background as needed. Before painting,

always Unselect the Frisket Pointer tool and select the Brush in the Toolbox. This will protect you from accidentally moving friskets off their location.

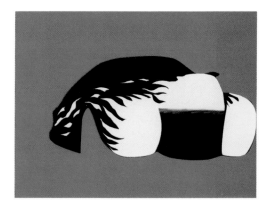

Step 4

Press down the shift key and select all the friskets that make up the flames, one by one. Use the Frisket palettes to represent friskets as color overlays. This way, feathering (see Section 3) is an easier task. Remember the number on the Feather slider. Fill the flames with yellow using the Fill bucket. Select the outline frisket of the car and feather as needed. Select Brush in the Toolbox, then choose white.

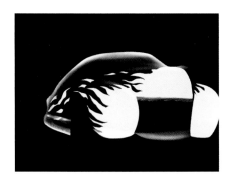

Step 5

Add other colors to enrich the highlights and shadows. Blend lightly with the Just Add Water device. Note, indicate the solar flare on the area of the hood and windshield. Develop a rhythm, alternating between the Airbrush and the Just Add Water tool. Airbrush in some hot spots, and create more solar flares, repeating the process as desired.

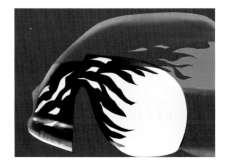

Step 6

Now, slow down a bit. It is time to be selective: Should the windshield be airbrushed before the fender? Or should the background be developed first? Experiment by selecting and developing an element of the image at random. In this illustration, the windshield is worked on first, because it will define the mood for the whole painting.

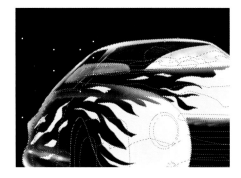

Step 7

Develop the sketch further, fleshing out headlights, grille, wheel-wells, and interior details. Notice how changing a detail, such as making the grille modern or the wheel-wells shallower, changes the whole mood of the painting. Art is often a clever balancing act between order and intuition, and here is one place where it lies in the balance.

Step 8

Paint the driver, the seats, and the side and rear windows using a combination of the digital wet-on-wet technique and outline masking. Take advantage of the Frisket Palette's positive and negative Frisket buttons to toggle between the Frisket and the background. Over-spray reflections in the windshield. Airbrush a hot spot in the upper left corner, and create a solar flare using the Just Add Water tool. Cross-hatch the radiator using the Rolling Edge, add highlights, and fill in the chrome work. ↙

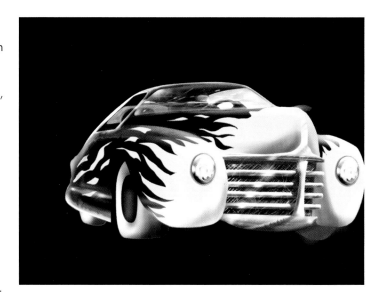

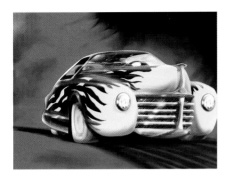

Step 9

Now it is time to create the background. First, block in the red. Use the wet-on-wet technique to soften up the area. Note, use the Distorto tool in the upper-middle area, where red meets black. Airbrush a suggestion of a road. Next, airbrush some red reflections on the underside of the fenders and wheels.

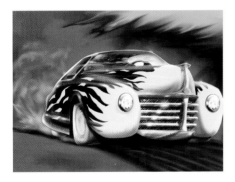

Step 10

Add a red glow to the windshield and left fender. Remember, work with both yellow and red to control opacity. Next, work on the dust clouds behind the car, using the Airbrush and the Just Add Water tool. Add accents with the Total Oil Brush.

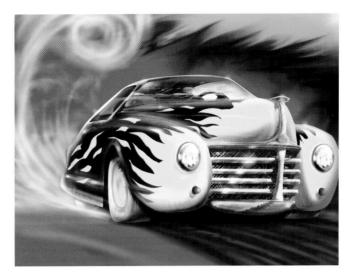

Step 11

Use broad strokes to create the swirling plumes that collapse on themselves, refining with the Distorto tool. Finally, unselect all friskets and apply the first airbrushed streak of dust over the bottom left side of the car. Add some hot spots by first using the Rolling Edge to draw thin highlights, and finish off with a burst of airbrush. Be bold. Airbrush a faint glow around the perimeter of the car.

Step 12

Reselect the outline frisket of the car and paint a darker clump of dust behind the exhaust to increase contrast. Next, create a lens flare by first blasting some white over the center of the flare, then, using the Rolling Edge tool, airbrushing lines radiating from the center. Make two passes, one using a broad and transparent stroke and pressing lightly on the pen, the other using a thin stroke and applying more pressure. Next, adorn with circular and polygonal flares using the opacity control in the Floating Selections window. Finish by adding additional thin airbrush strokes around the car to suggest air flow.

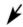

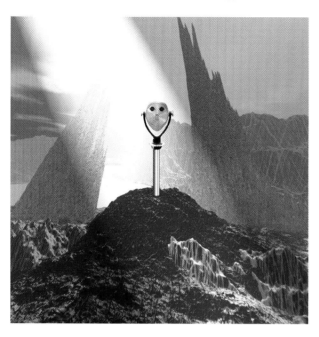

Idol
Technique: Painting Photographs, Digital Collage, Virtual Masking, Digital Airbrush, Painting 3D Images
Gary F. Clark

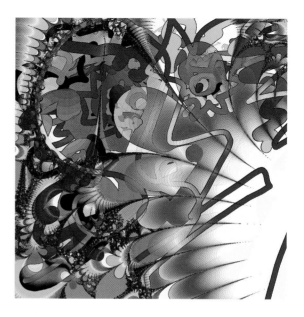

Triffelmar
Technique: Wet-on-Wet, Digital Collage, Virtual Masking, Digital Airbrush
Corinne Whitaker

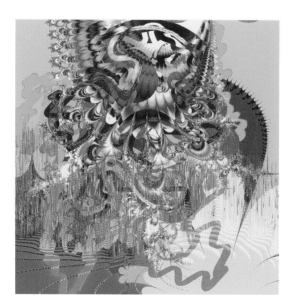

Pashtar
Technique: Wet-on-Wet, Digital Collage, Virtual Masking, Digital Airbrush
Corinne Whitaker

Oh, Look! The Dragon's Back!
Technique: Digital Airbrush, Virtual Masking, Wet-on-Wet
Todd DeMelle

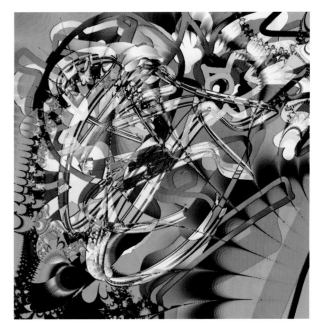

Abln Pssn
Technique: Wet-on-Wet, Digital Collage, Virtual Masking, Digital Airbrush
Corinne Whitaker

Immersion
Technique: Painting Photographs, Digital Collage, Virtual Masking, Digital Airbrush
Gary F. Clark

Poser
Technique: Painting 3D Images,
Digital Airbrush
John Derry

Dawson Design Logo
Technique: Painting 3D Images, Digital Airbrush
Henk Dawson

Lily Pond
Technique: Wet-on-Wet, Virtual Masking, Digital Airbrush
Stacy A. Hopkins

Clouds
Technique: Wet-on-Wet, Digital Airbrush
Dewey Reid

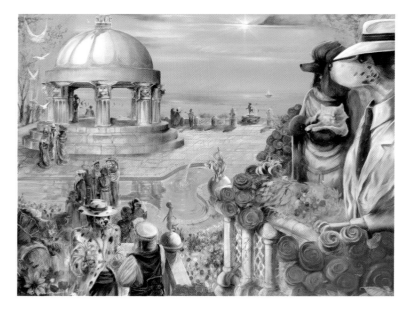

The Great Gatsbone
Technique: Wet-on-Wet, Virtual Masking, Virtual Trace Paper, Digital Airbrush
Mario Henri Chakkour

Rasterops
Technique: Digital Airbrush, Painting Photographs, Painting Words, Wet-on-Wet,
Painting 3D Images, Digital Collage
Dewey Reid for Colossal Pictures

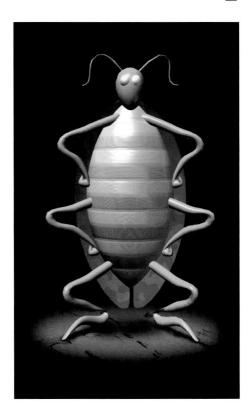

The Bug
Technique: Painting 3D Images, Digital Airbrush
Henk Dawson

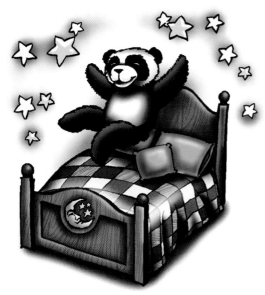

Penda Bed
Technique: Digital Airbrush,
Wet-on-Wet, Virtual Trace Paper
Scott Fray

Happy Heart
Technique: Digital Airbrush, Wet-on-Wet, Virtual Trace Paper
Scott Fray

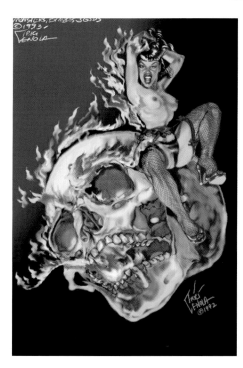

Screaming Betty Page
Technique: Wet-on-Wet, Virtual Trace
Paper, Digital Airbrush
Trici Venola

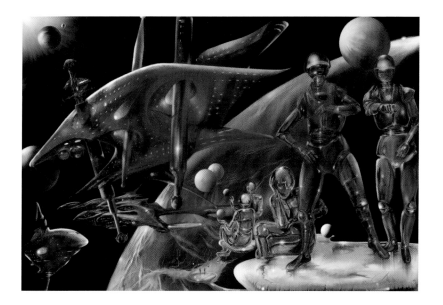

Final Harvest
Technique: Wet-on-Wet,
Virtual Masking, Virtual Trace
Paper, Digital Airbrush
Mario Henri Chakkour

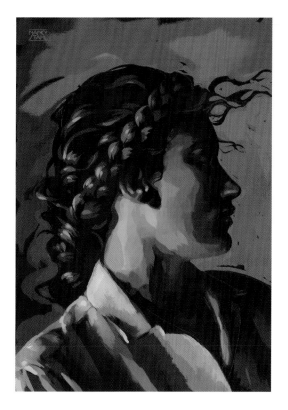

Si Braid
Technique: Wet-on-Wet, Virtual Masking,
Virtual Trace, Digital Airbrush
Nancy Stahl

PAINTING

PHOTOGRAPHS

Brick Facade *Philip Howe*

So far, all the images in this book have been created from scratch, without relying on scanned images. That is not to say that scanning is bad for one's health or that altering images with filters is taboo. The point of the first four examples was to show that computers can be tools that allow the same amount of creative fluidity normally associated with traditional tools. Digital tools like Adobe Photoshop, Macromedia Xres, and HSC Live Picture, though, have few parallels in the traditional world. Yet despite their technical firepower, they cannot alone transform a traditional scan into artwork.

Both criteria can be found in scanning, of course. Take the next exercise, for example, which features a photograph of a car. The image needs a little help: the colors are a little flat and the polished glass and painted metal need brilliant light and dark reflections, deeper colors, and more translucency. All of these requirements cannot be solved by mere sliders and filters; color correction can do only so much—one cannot adjust what is not yet there. Adding color in a paint program will give a scan the "photo-realistic" look, the holy grail of digital photography that the chemical developing process still does better than the scanner even when color-correction is used. Thus, the old-fashioned traditional photo-retouching approach applies. For this, all the hard work applied in the previous section will come in handy.

Even if the images are not yet big enough, the truly important focus is to develop "wrist action" and self-assurance; the technology will catch up. Another philosophical question is raised when delving into this facet of painting on the digital canvas: When does retouching become painting? Perhaps it is best left for the philosophers. Software companies, on the other hand, don't seem to worry about such grand debates.

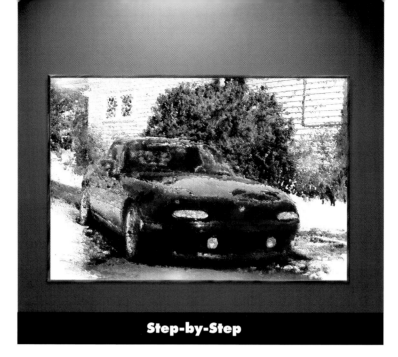

Step-by-Step

Dave's Baby

Software: Painter 2.0, 2.0 X2, 3.0 or later, and Adobe Illustrator if using Painter 2.0 and 2.0 X2 for creating Bézier curves

Hardware: Apple Macintosh Quadra 700, 20 MB RAM, 230 MB hard drive, Sony 16"-inch monitor, Apple 13-inch monitor for palettes, 24-bit color, Wacom ArtZ Tablet (8.5" x 6")

Image Size:
Initial scan is done at 300 dpi yielding a 1200 x 900 pixel image.

The brushes used in Painter include:

- Total Oil Brush (Liquid: Total Oil Brush) for elaboration and fine details.
- Airbrush (Airbrush: Fat Stroke) for soft color build-up, glazing, elaboration, and fine details.
- Water (Water: Just Add Water) for blending colors, washes, form definition, and atmosphere.
- Distorto (Liquid: Distorto) for character and effect.
- Soft Cloner (Cloners: Soft Cloner) for an airbrush-style cloning.

®1995 photo: Dave's Baby, Environmental Enterprises.

Scanning to Paint

Scan the photograph at the highest resolution possible without taxing the system and locking it up. Be aware that even if the best tools are used to match monitor color to output color, there is still the matter of ambient light and inks that can change a color's appearance. Even camera-ready art looks different under different lighting conditions. As explained briefly in Section One, color is both a matter of experience, trial and error, technology, and luck. Before it comes time to start the press, the printer and the artist must communicate.

Step 1

Once the scan is color-corrected and the size is final, settle in to the task of patiently creating masks from paths. Save as Dave's Baby. Don't rush to grab the magic wand and let the CPU create masks; the only way to create perfect masks is to draw curved selections with the outline selection tool's Bézier curve drawing style. To discern detail, create a scratch file and reduce the brightness and contrast. Increase the brightness to full on the monitor, remembering to reduce it to the recommended level afterward. Also remember that the brightness control on the monitor should be reduced to about half in most cases, depending on the ambient light.

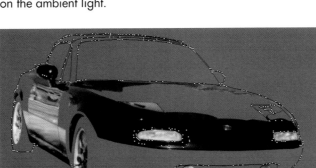

Step 2

Plan ahead: Which parts of the image need masks? Shiny, metallic surfaces are smooth and mirror-like and reflect bright highlights and high contrast, as well as absorb light. These areas of light and dark are distinct; however, they should not be treated as separate surfaces as a result of overindulgence with masks.

Step 3

The passenger's side window is the first on the list; it reflects the sky and the house facing the car. It is a little washed-out, and needs highlights. With the Total Oil Brush set very thin, gently add some turquoise. Then darken the shadows with dark brown and lighten the light areas with white. The only mask needed here (not shown) is one that covers the passenger window. The magnification on the screen can be increased to gain more control. Note the solar flare on the passenger's side rear-view mirror.

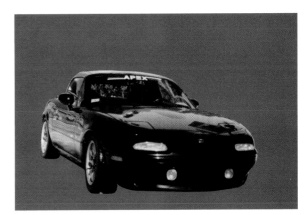

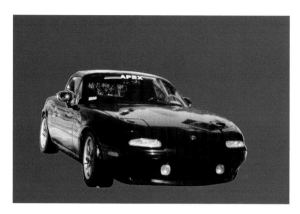

Step 4 ✦

Next, highlight the vent window. The passenger's side rear-view mirror gets a traditional digital airbrushing treatment, exercising some artistic license with regard to the shape of the reflections. Follow with a burst of airbrush over the original sun spot, followed with radiating lines with the Water tool, set very thin. With the Total Oil Brush, increase the dark values in the convertible top. Follow with Distorto, very thin, to darken and pull the shadows into elegant tentacles. When using the Distorto tool, it helps to pretend that the canvas is made of molasses and move slowly.

Step 5

Add a gently airbrushed turquoise to the fender and an additional burst of Airbrush to the solar hot spot above the left (looking at the image) parking light. The two parking lights are next. Keeping the Total Oil Brush very thin and white, add to the fragmented reflections in the lenses.

Step 6

With the brush, add streaks of white highlights to the reflections on hood. Add a thin turquoise line around the edge of the reflected roof. Note how the line bends around the seams; think of these reflections as a heavy, mercury-like liquid. Notice how the light bends around the right headlight intake scoop. In each case, follow with a light Airbrush burst to duplicate the glow associated with highly reflective surfaces. ↘

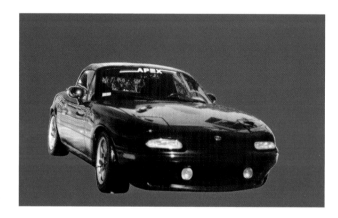

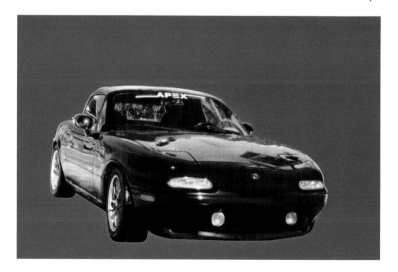

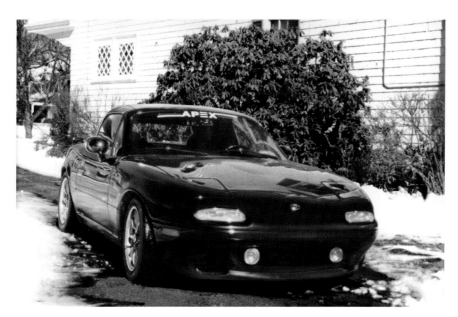

Baby." Point and click on the cloned image. Watch how dabs of pixels appear. What is happening? Notice on the clone source the crosshairs in the source file. Clumps of pixels are processed one dab at a time. Brush strokes are not permitted in this case. Try it: The result is merely a repetition of the first few pixels targeted by the crosshairs. Add a couple of brush strokes now and then to give the illusion of mistakes, but for the most part, this is a stipple technique. The good news is that two artists cloning the same image will never get quite the same result. In fact, clicking the pen more than once in the same spot will always produce different results. The first part of the process may take several hours. Next comes the hard part—texture.

Step 7 ↗

Once all the elements are retouched, analyze the background. Enhance the snow with white and increase the contrast in the background. The resulting image is still a photograph, but crisper. True, the quaint background does not create a race car "atmosphere." It can be altered radically substituted, for example, by a sleek showroom with colorful lights and wet floor—but that ignores the problematic reflections. In Painter, clone the image by selecting all, deleting and clicking on the Tracing Paper button.

Step 8

Select Brushes: Cloners: Oil Brush. Assuming the commands File: Clone and Edit: Select All were engaged, there should be a new and empty white image named "Clone of Dave's

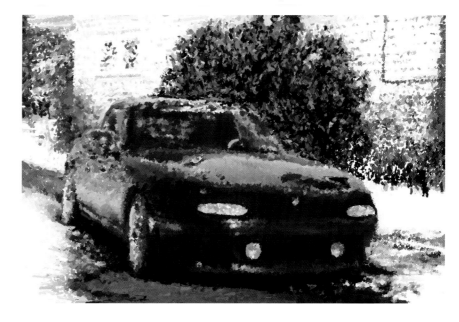

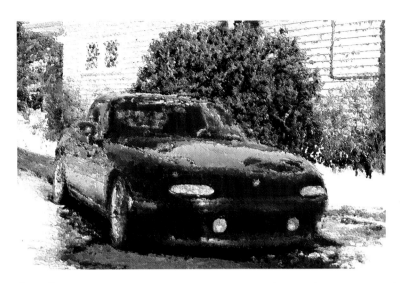

Airbrush, apply some thin streaks to imply light bouncing off the varnish. Highlight some areas with white dots using Brushes: Pen-and-Ink. This will enhance the reflective quality of the varnish. Access Canvas: Canvas Size next and add 15 pixels around the perimeter of the painting. The image should be surrounded with blank space. Using the Edit: Magic Wand, create a selection. Paint a fake frame with the Digital wet-on-wet and Freehand Airbrush. Use Draw Straight Lines in the draw style to render the shadows and highlights.

Step 9

Is this image intended as a painting or a photograph of a painting? In general, "real paintings" have texture. To apply it, select Effects: Surface Controls: Apply Surface Texture while in the clone source file, "Dave's Baby." In the surface texture dialog box, choose Using 3D Brush Strokes from the pop-up menu. Select Shiny and choose a light direction.

Step 10 ➤

Next, to apply an even more realistic feel to the surface, select an area with the Freehand Selection tool; feather and float it; then Undo.* Select the floater. Change the paper texture by choosing Hatching from Window: Art Materials: Papers. Apply this new texture to the area in the floater then apply a surface texture to the floater using the same steps above except selecting Paper Grain instead.

Floating the area can reduce the opacity. (Remember to undo after floating; otherwise, the floater will leave a hole underneath it.) Once many areas are floated and are treated with Hatching, opacity levels can be played with. Feather to achieve a more natural look. Next, with the

*Since the writing of this book, version 3.1 of Painter was released, requiring the following update regarding floating selections. If using version 3.1 to get rid of the halos, follow this procedure: Make a scratch copy of the original painting; float the selection; note the coordinates of the floaters; copy floaters; paste floaters in scratch file. That will take care of the halo effect.

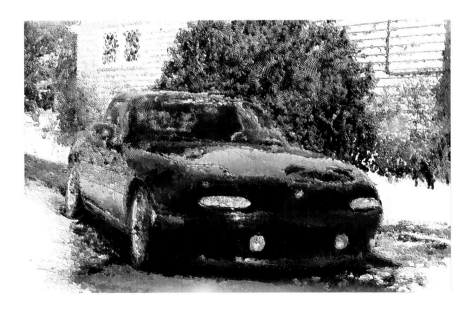

Step 11

The plot thickens. Select all and copy, open a new image, and paste. Do not drop it yet. Add some lighting by selecting Surface Controls: Lighting. For this illustration, one light source, "Plain," was chosen. In Painter, select the Outline Selection tool with Straight Line drawing style to create the Outline Selection for a drop shadow. Using the outline selection tool instead of the rectangular selection tool has its advantages. First, the selection tool can be distorted to mimic a correct shadow behind the image, that is, because the hung image usually leans forward, the shadow will be tapered. Feather first and then float the selection. Send back the selection behind the first floater. Fill using the Fill Bucket. Reduce the opacity and increase the feathering until the desired effect is achieved.

Step 12

The hot spot on top is still a little weak. To remedy that, grab the Airbrush; increase the size; reduce the magnification on the screen; point the cursor outside the image field; and move with a gentle, circular motion.

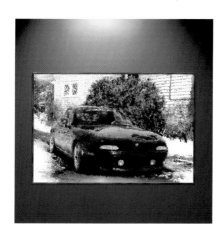

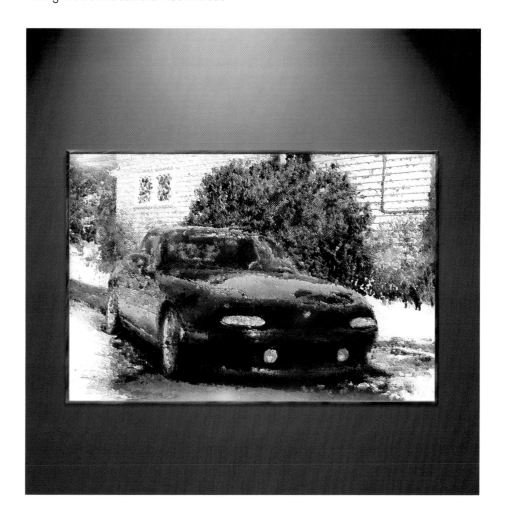

Like Ancient Ants
Technique: Painting Photographs, Digital Collage, Virtual Masking, Digital Airbrush, Painting 3D Images
Gary F. Clark

Postcards From the Digital Highway/Stop#4
Technique: Painting Photographs, Digital Collage, Virtual Masking
Gary F. Clark

Postcards From the Digital Highway/Stop#1
Technique: Painting Photographs, Digital Collage, Virtual Masking
Gary F. Clark

Everything That Moves Can be Measured
Technique: Painting Photographs, Digital Collage, Virtual Masking,
Wet on Wet
Gary F. Clark

The Crow's Road
Technique: Painting Photographs, Digital Collage, Virtual Masking
Gary F. Clark

Peeks
Technique: Painting Photographs, Digital Collage, Virtual
Masking, Wet on Wet
Gary F. Clark

The Centaur
Technique: Painting Photographs, Digital Collage,
Virtual Masking
Dorothy Simpson Krause

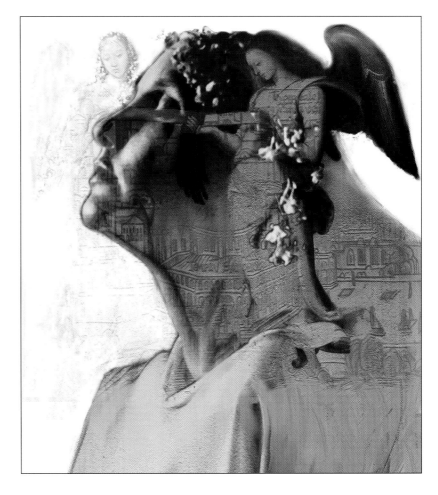

Messages
Technique: Painting Photographs, Digital Collage, Virtual Masking
Dorothy Simpson Krause

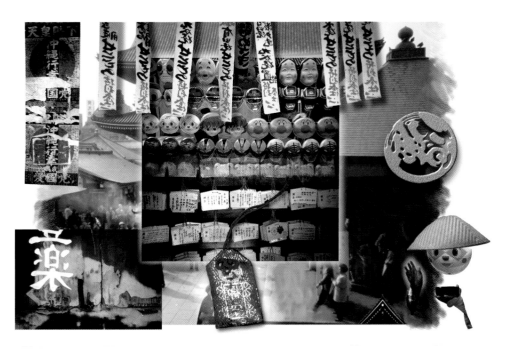

Asakusa
Technique: Painting Photographs, Virtual Masking, Digital
Airbrush, Digital Collage
John Derry

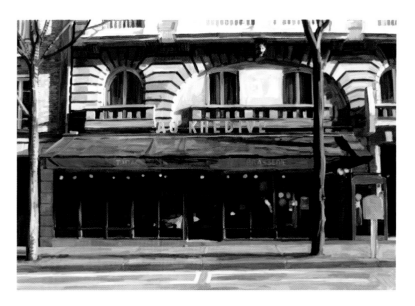

Au Khedive
Technique: Painting Photographs
John Derry

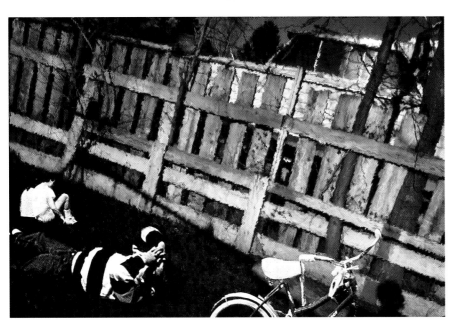

The Playground
Technique: Painting Photographs
Michael Cinque

Softball Carrier
Technique: Painting 3D Images, Painting Photographs
Max Probasco

Cyclist

Technique: Wet-on-Wet,
Painting Photographs
Digital Collage,
Painting 3D Images
Dewey Reid for
Colossal Pictures

Sax Man

Technique: Painting Photographs
Photography by Ed Lowe, Digital
Manipulation by Philip Howe

Incas

Technique: Wet-on-Wet, Virtual Masking, Virtual Trace Paper, Digital Airbrush,
Painting Photographs, Digital Collage, Painting 3D Images
Dewey Reid

DIGITAL

COLLAGE

Sin and Simple Shell *John Sledd*

■ Collage, derived from the French verb *coller*—to stick with glue—is the mainstay of digital artists as it becomes easier and easier to stick images from many sources into a single digital painting. Even though digital collage is still young compared to its traditional cousin, the medium has progressed rapidly since "copy and paste" became part of the computer artist's everyday language.

In fact, most newcomers who enjoy the ease of floating selections do not realize that their digital forefathers had no such luxury. For them, only one selection could be pasted at a time, and once the selection was "glued" to the image, it was there to stay.

Today, several selections can float at the same time and stay floated until the artist decides to "drop" them. Together with that leap in technology is the myriad of effects each selection can undergo. But what about content? Since the majority of collage relies on the arrangement of heterogeneous elements rather than brush strokes, conveying the artistic experience is even more of a challenge.

Just as digital brushes must work in unison to create the complex overtones that make up an artist's unique style, the collage and special effects can produce even richer results. That is why the artist should keep a log that describes the steps that went into creating a particular look.

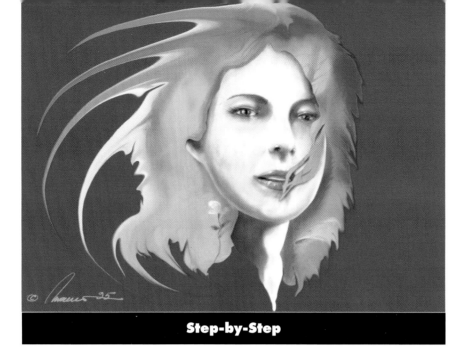

Step-by-Step

Elizabeth

Software: Painter 2.0 X2, 3.0 or later, and Adobe Illustrator if using Painter 2.0 and 2.0 X2 for creating Bézier curves

Hardware: Apple Macintosh Quadra 700, 20 MB RAM, 230 MB hard drive, Sony 16-inch monitor, Apple 13-inch monitor for palettes, 24-bit color, Wacom ArtZ Tablet (8.5" x 6")

Image Size: Initial sketch is 640 x 480 pixels. Image is then scaled up to 1200 x 900 pixels before execution.

The brushes used in Painter include:

- Charcoal (Charcoal: Soft Charcoal) for rough massing of colors.
- Water (Water: Just Add Water) for blending colors, washes, form definition, and atmosphere.
- Total Oil Brush (Liquid: Total Oil Brush) for elaboration and fine details.
- Airbrush (Airbrush: Fat Stroke) for soft color build-up, glazing, and elaboration and fine details.
- Distorto (Liquid: Distorto) for character and effect.
- Soft Cloner (Cloners: Soft Cloner) for an airbrush-style cloning.

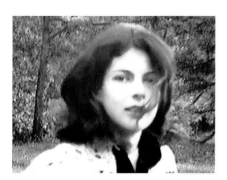

Step 1

Start with a photograph, such as this black and white portrait. Because the picture was mounted, the portrait was scanned with a Hi-8 video camera instead of a flatbed scanner, which would have been impossible. The quality of the scan is not critical since the portrait will be transformed into a painting shortly. This scan yielded an image that was 640 x 480 pixels and was therefore resized to 1200 x 900. In fact, if using Macromedia Xres, which also provides painting and cloning features, the file can easily be 6000 x 3000 or more! For now, this exercise will take place in Painter 3.0; Photoshop and PixelPaint Pro3 also work well for this technique.

Step 2 ↗

With the Water tool set at 100 percent opacity in the Controls: Brush palette, smooth the pixels. Experiment with different opacity levels. Do not overblend, especially around the eyes and mouth. If necessary, lower the opacity and/or brush size to eliminate pixellation. Increase the screen magnification, and have some reference images

at hand, too, since reconstructing the mouth and eyes is often difficult. Don't attempt to render the eyes too much; a gentle touch will do for now. Note a couple of highlights on the mouth and nose, as well as the simple suggestion of teeth.

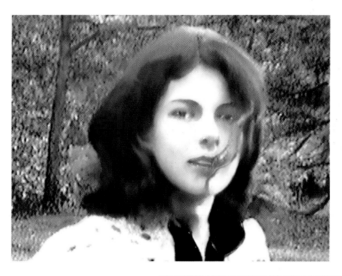

Step 3 ↖

Using a combination of Airbrush and Water, start amassing some ocher and pink. Blend. Next, apply some dark values to the face, further defining its valleys and ridges. Apply shadow on the bottom middle part of the nose; to its sides and the concave and convex surfaces right underneath; to the lateral angle of the mouth where the upper and lower lips join, and the concave part under-

neath; and to the nostrils. Define the larynx. With the Total Oil Brush (see appendix B) set to a light brown, render the iris and the pupil in black. Always work on both eyes at the same time. Add highlights with white to the sides of the nose and the lips.

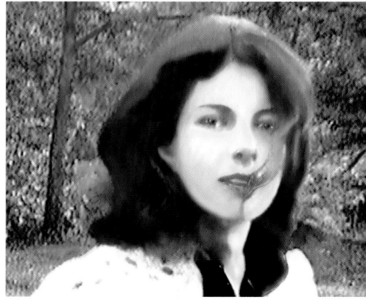

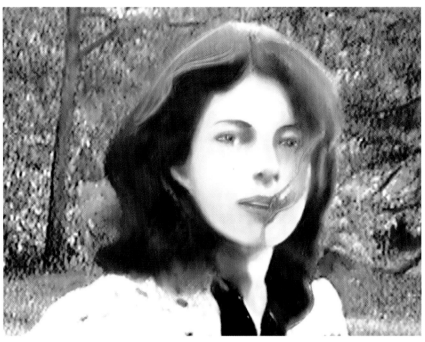

Step 5 ↓

More blending yields a soft, pleasing effect. Note that in this example, the hair will wrap around the face. Should the background be discarded or merely retouched? Unfortunately, due to the lack of detail, it is better to discard it. Besides, the background starts to look a little bland when compared to the figure. One sure way to find out is to make a test.

Step 4 ↗

Still using the Total Oil Brush very thinly, subtly define the eyebrows. It's all right to draw outlines every now and then to enhance the definition, such as around the eyelids and mouth. During this process, keep the subject's personality and soul intact—this should be a labor of love, even more so than any other artistic endeavor, because it requires the artist to remain somewhat objective.

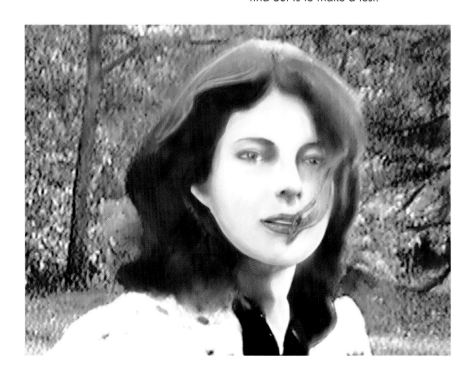

Step 7

Remember the wet-on-wet technique? Time to have fun with the Airbrush blasting the hair with red. Highlight with white charcoal. Apply some yellow ocher to the background. Interesting, but not quite there yet. Maybe combining two images will supply that missing link. ↓

Step 8

Enter Image 2, a painting of a flower in the desert. There are a few problems, however: Each image has a different proportion. What part of what image should be merged and how? Is there a way to place one image on top of the other, just like on a light table, to study their relationship? Unfortunately, no matter how enlightened it is, the software will not resolve any of these creative issues. Treat the figure as Image One and the landscape as Image Two.

Step 6 ↑

Carve masks: one facial mask, one hair mask, four hair holes masks and one neck mask. Note that the holes in the strand of hair over the face were created from selections that were not assigned negative values using the Negative button in Objects: Paths List. Remember, in Painter, to create hole-within-a-hole mask like a donut, the outer mask is positive; the inner, negative. Here, since the facial mask does not enclose the hair holes, they should remain positive. Activate the mask using the Visibility buttons (mask is feathered to 1.7). Now that the background is gone, it's a different matter.

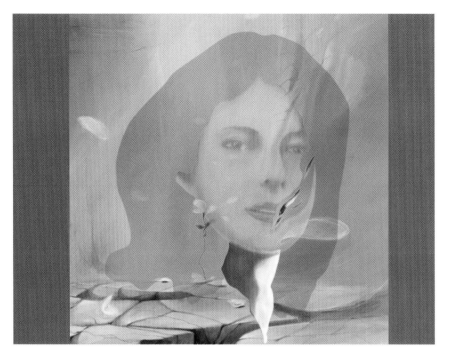

Step 9

Assuming Image One is what the final image will turn out to be in size and proportion, create a new file that same size—1200 x 900 pixels—called Image Three. Select all of Image Two and copy. Select Image Three and paste Image Two into it. Image Two will appear as a floater. In Image One, float every item as outlined in section 4, step 6; group, name, record the coordinates (once the location of the figure has been resolved); and copy the group of floaters. Select Image Three and paste again. To reposition the figure correctly, enter the coordinates after double-clicking on the group name in Objects: Floaters List and once the Floater Attributes box appears, key in the recorded top and left coordinates

in the Position dialog boxes. Again, always remember to undo right after floating to get rid of the unsightly halo* that appears. For this demonstration, the figure floaters were ungrouped and each floater's opacity was altered, also helping when positioning and/or rescaling Image Two. Group the figure floaters if they will be moved.

*Since the writing of this book, version 3.1 of Painter was released, requiring the following update regarding floating selections. If using version 3.1 to get rid of the halos, follow this procedure: Make a scratch copy of the original painting; float the selection; note the coordinates of the floaters; copy floaters; paste floaters in scratch file. That will take care of the halo effect.

Step 10

Now that the position of the landscape in Image Three is set, discard the figure. Drop the landscape floater. Copying information in Image Three in order to paste within the floating figure must not be a crude maneuver but a gradual sprinkling of information, a cloning or rubber stamping. Choose Edit: Clone Source: Image Three. Image Three is now the source. Choose and treat the Cloners: Soft Cloner brush like an Airbrush. Rather than spraying color from the palette, however, it will transfer the pixels from the clone source. Note the "target cursor" in the source file when the two images are put side-by-side. Activate the hair mask (or floater if still floating) and proceed to clone as desired by painting in the hair. Vary the pressure while doing so to get a feathered effect. Mix with the Airbrush and Distorto tools. Apply white and red highlights, then squiggle the Distorto to create a teased effect.

Step 12

More Distorto. Also, and this is called cheating, use the Total Oil Brush to retouch some areas by picking up the color of the background with the Eyedropper tool and carefully shave off some areas of the wild hair at a higher magnification (in this case 200 percent). The Distorto tool also may be used to further define the eyelashes. Note the addition of darker tones to define the facial areas, such as the cheekbone, the eyes, and the area under the mouth.

Step 11

Drop all the floating selections. Perm the hair with the Distorto brush. Experiment with different sizes. Use a combination of zigzag and curvilinear movements. Sometimes, drag the background in; other times, drag the hair out. Note how the increase in speed thins out the brush. Using a brush like Distorto effectively requires familiarity with the lag between the hand movement and the reaction of the brush, which ultimately depends on the processing speed of the machine.

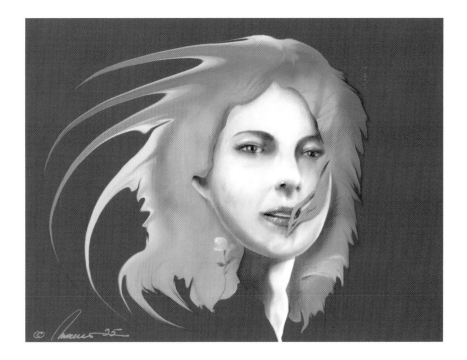

Mike
Technique: Wet-on-Wet, Virtual Trace Paper, Digital Collage
Jan Ruby-Baird

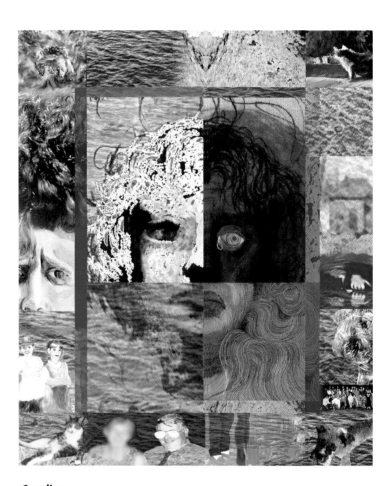

Caroline
Technique: Wet-on-Wet, Virtual Trace Paper, Digital Collage
Jan Ruby-Baird

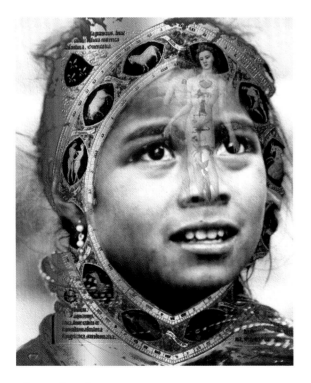

The Books of Hours
Technique: Painting Photographs, Digital Collage, Virtual Masking
Dorothy Simpson Krause

Postcards from the Digital Highway/Stop#2
Technique: Painting Photographs, Digital Collage, Virtual Masking
Gary F. Clark

Dicates of Conscience
Technique: Painting Photographs, Digital Collage,
Virtual Masking
Gary F. Clark

Tree of Life
Technique: Painting Photographs, Digital Collage, Virtual Masking,
Digital Airbrush, Painting 3D Images
Gary F. Clark

Fthr Hg
Technique: Wet-on-Wet, Digital Collage, Virtual Masking,
Digital Airbrush
Corinne Whitaker

A bridge of Technologies & Ideas
"Technology reflects the human mind,
without ideas machines we become"
Technique: Painting Photograph, Digital Collage
Andy Gordon

breakinG ouT
Technique: Wet-on-Wet, Digital Collage, Virtual Masking,
Digital Airbrush
Corinne Whitaker

Global Networks
Technique: Painting 3D Images, Digital Collage, Digital Airbrush
Henk Dawson

Back of the Bus
Technique: Painting 3D Images, Digital Collage, Digital Airbrush
Henk Dawson

Pyramid
Technique: Painting Photographs, Painting 3D Images, Digital Collage
Victor von Salza

Sky of Kisses
Technique: Painting Photographs, Painting 3D Images, Digital Collage
Victor von Salza

Green and Gold
Technique: Digital Airbrush, Wet-on-Wet, Virtual Trace Paper, Painting Words, Digital Collage
Scott Fray

Scarab
Technique: Wet-on-Wet, Virtual Masking, Virtual Trace Paper, Digital Airbrush, Painting Photographs Digital Collage, Painting 3D Images
Dewey Reid for Colossal Pictures

Obsidian
Technique: Digital Airbrush, Wet-on-Wet, Virtual Trace Paper, Painting Words, Digital Collage
Scott Fray

Found Garden-Revelation 3
Technique: Digital Collage, Wet-on-Wet
Karin Schminke

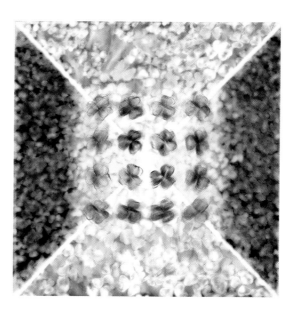

Found Garden-Revelation 4
Technique: Digital Collage, Wet-on-Wet
Karin Schminke

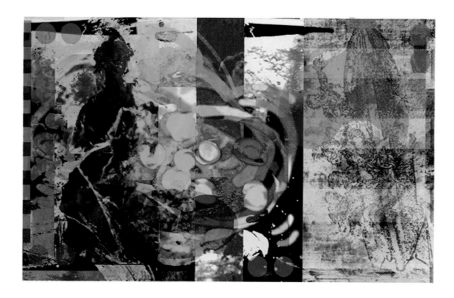

Joyride 2
Technique: Wet-on-Wet, Painting Photographs, Digital Collage
Steven P. Goodman

PAINTING

WORDS

Reebok 100 #2 Graphic Design by Stoltze Design, Image by Planet Interactive

Words are made up of letters, symbols reflecting the moods, art, architecture, and social values of civilization. Whether the result of precise geometry or flawless hand movement, recorded with ink on paper or chisel against stone, words speak a complex, silent language while simultaneously pleasing the eye.

The introduction of the digital painting medium has equipped the designer with the power to research and develop typographical styles that are costly to produce otherwise. However, painting with computers produces bitmapped images that are resolution dependent; the bigger the image, the better the output quality. This is an important factor when deciding whether or not to create type in bitmap.

Painter and PixelPaint create and manipulate pixels whose number determines the quality of the output. Programs like Adobe Illustrator, on the other hand, create "resolution-independent" images are files that rely on mathematical functions (formulae) to describe lines and curves. They may be enlarged or reduced in size without suffering any loss of quality in their output.

PostScript is only one of many drawing languages but it is de rigeur on the Macintosh; HP PCL5 is common on the PC side. Usually, type is created using a page description language combined with the bitmap. QuarkXPress, for example, can be used to combine PostScript and TIFF in a single file. When special effects are called for, however, or when words are part of the painting, the only way to achieve such results is by using painting software throughout the process. Bitmapped type also aids the design process: Using painting software to design a page provides a higher resolution preview of the work, thus saving on printing costs in the initial stages of the design. In the following exercise, a custom-carved title will be created using masking brushes.

Angels

Software: Painter 2.0 X2, 3.0 or later, and Adobe Illustrator if using Painter 2.0 and 2.0 X2 for creating Bézier curves, or Pixel Paint Pro 3

Hardware: Apple Macintosh Quadra 700, 20 MB RAM, 230 MB hard drive, Sony 16-inch monitor, Apple 13-inch monitor for palettes, 24-bit color, Wacom ArtZ Tablet (8.5" x 6")

Image Size: Initial sketch is 600 x 900 pixels. Image is then created using a series of scaled up-up steps up to 1600 x 2000 pixels.

The brushes used in Painter include:

- Chalk (Chalks: Sharp Chalk) for rough initial sketching and composition.
- Charcoal (Charcoal: Soft Charcoal) for developmental sketching and rough massing of colors.
- Water (Water: Just Add Water) for blending colors, washes, form definition, and atmosphere.
- Total Oil Brush (Liquid: Total Oil Brush) for elaboration and fine details.
- Airbrush (Airbrush: Fat Stroke) for soft color build-up, glazing, elaboration, and fine details.
- Distorto (Liquid: Distorto) for character and effect.
- Masking Pen (Masking: Masking Pen) for editing the mask layer.

In Pixel Paint Pro 3 the tools include:

- Airbrush for soft color build-up, glazing, elaboration, and fine details.
- Finger Tool for blending colors, washes, form definition, and atmosphere.
- Waterdrop Tool for final smoothing of the blended areas

Step 1

Start a new painting in Painter or PixelPaint; save the file. This is a preliminary phase as the image is smaller than the final product. During the conceptual stages, the brushes will need to work at peak performance, so for now the file is 600 x 900 pixels. Using a scratch copy, rough in some idea of type with the Charcoal or Airbrush tool. Don't worry about the details for now. Early attempts indicate that the main title will fit in the middle to upper top corner; the author's name might fit in the top right corner; and some type may reside at the bottom. Secondary titles will fit in the bottom part.

Step 2 ↗

Creating type with PixelPaint is similar to doing it in Photoshop. Once the cursor is placed and clicked, a text editor appears. In most cases, using Adobe fonts requires Adobe Type Manager,

except when using Painter 2.0. If that is a hassle, generate the text in 2.0, float it, and then open it in 3.0. To transform the text into a floating selection in PixelPaintPro3, turn the Pixel Layer on and choose Select: Pickup once the text appears surrounded by a dotted box. Make sure kerning is done *before floating*. Placing letters in Painter is a different matter: There is no Text Entry window. Instead, click and type on the canvas. The letters literally will be dropped in as individual friskets. In this particular case, True Type fonts were used to create floating selections in which the letters were rendered separately. Because bitmaps are "resolution-dependent," the type needs to be as large as possible. Here, the type is created on a file that is 1400 x 1400 pixels.) Feather and smooth as needed, watching for pixellation after applying color. Adjust the feathering to soften the edges without blurring.

Step 3

After a design review, it becomes clear that the title needs a more fluid approach. Try a freehand sketch with the Airbrush on a separate page 1600 x 2000 pixels. Although the type might be bigger than needed, that can be corrected later. Next comes the task of literally carving out the type. The following two methods advocate covering the image with a rubylith-like layer and carving out the unwanted pieces: The mask will be carved directly or painted in, depending on whether the mask layer is reversed as opposed to using tools to create selections from which masks are derived.

Step 4

Painting or carving into a mask requires masking brushes. While selection tools are limited to the perimeter of objects, masking brushes create masks with 256 levels of opacity throughout. Carving through a mask directly is faster, but as always, there are trade-offs: In Painter, the masking brushes can only be used in Freehand or Straight Line modes. In PixelPaint, Bézier lines can be stroked; however, the thickness of the line cannot be changed. In Painter, select the upper right and lower middle Drawing and Visibility buttons and the Transparent Mask in Objects: Path List. Brushes: Masking: Masking Pen is used to carve the mask. In Painter, to carve or subtract from the mask while the middle upper Drawing and Visibility buttons are on, select black (hue, saturation, and value set to zero in the Colors palette). To edit or fill in the mask, choose pure white. Reverse when the far upper right Drawing and Visibility buttons are on. The gold color is applied with the Paintbrush tool in order to better view the mask's progress.

Step 5 ↘

In PixelPaint, click on the Mask button in the upper right side of the document window to toggle through different mask modes. Choose Mask Only. The image—the sketch of the title—will become grayscale. Select the Airbrush tool and set the size to about nine pixels, density slides all the way to the left, the flow to about 25 percent and the spatter to zero and paint. Notice that,

although the Airbrush paints red, there is no color at all; this is merely mask material being airbrushed over the title. To edit, use the eraser and reapply. In this mask mode, any brush is a masking brush. Select Mask: Reverse and the image will be covered with red; the brushes, therefore, "carve" rather than apply masking material. In Painter, toggle the Mask Visibility buttons and select a masking brush. The color of the mask can be selected in the Mask Color box in Objects: Paths List. Remember, the color of the mask should merely aid in viewing the mask: A mask is just a shield. If painting a mask, simply reverse the steps.

Step 6

Now that the mask has been carved in Painter using the masking brush to feather, use Edit: Mask: Edit Mask paint. In PixelPaint, to paint in the Mask area, toggle the Mask button and select Use Mask. Does the type need to be shrunk to fit perfectly within the proportions of the background? In painter, before importing the title into the background, follow this procedure: Select all then copy and paste the title page in the background image. It will appear as a rectangular floating selection. Choose

Effects: Orientation: Rescale until it is proportional, and experiment. Jot down the ratio that looks best. Discard the floater and go back to the title page. Select Pointer to create the outline selection of the mask, which turns all the individual brush strokes into selections. Note that they are all activated. Using Effects: Orientation: Scale, enter the ratio that was jotted down. This will rescale the title, turning it into a floating selection.

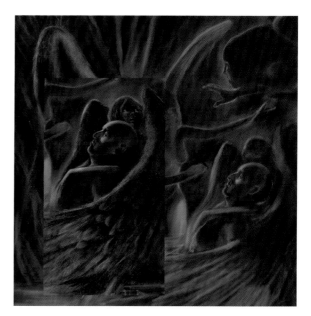

Step 7

Because of its size and the number of paths and floaters involved in its creation, the final background was subdivided into sections selected at random. Each section was subdivided into smaller chunks using the Rectangular Selection tool, floating the area, noting its coordinates, copying, and choosing Edit: Paste: Into New Image. The file was then saved along with recorded coordinates, which were worked on separately. Once the operation was finished, the image was copied and pasted into the final background image and the coordinates were entered in Objects: Floaters list (Section Seven). In PixelPaint, and any time there is no floater coordinates indicator, simply rough it. Paste the patch and put the Pixel Layer on. Choose a selection tool. Reduce the opacity of the patch in order to view the background below. Move the patch roughly into position, then zoom in. Locate a pixel that stands out from the rest. There should be one just like it in the background below

the floater. With the pointer, drag and place one pixel on top of the other, and it should snap into place, aligned perfectly. Bring the opacity back to 100 percent. To double check, slide the opacity between 100 percent and 0 percent and watch for a shift in the image.

Mounir Youssef Murad

top one, and use the Eyedropper to pick a color from the main title. Fill with the Fill bucket and repeat until satisfied with the result. To resize the title, regroup first and select Effects: Orientation: Scale. A Scale Group By window will

Step 8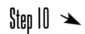

A further design review indicates that the name of the author should go at the bottom. On a separate file, whose size is 2551 x 600 pixels, and using the method in Step Two, create the title. Feather as needed. Unlike Step Two, however, the type will be filled with the Fill Bucket. In Painter, each letter is a separate path, and all paths lead to friskets. To kern and resize the letters, make sure they are selected. To fill the selected letters with color, float the title, then fill and deselect the Show Selection marquee in Objects: Floaters list to better judge the quality of the outline. Then copy the floater and paste on the same page. Now fill with white. To move one floater on top of another, select the Floating Selection tool and press the Front button in Controls: Floating Selection. To turn the bottom title into a drop shadow, simply increase the feathering using the slider. The opacity can also be controlled using the opacity slider. Position the bottom title using the up and down arrows on the keyboard. Group the floaters.

Step 9

Back to the main title, which is already a floating selection ready to be imported from Painter. To float the mask in Pixel-Paint, reverse the mask to cover the type. Then choose Mask: Put Mask into Selection. Put Pixel Layer on and activate a selection tool for any feathering. This allows access to Select: Modify: Feather. Paste the type in the background and fill it with black. Paste it again and move it in position to create a crisp shadow. Remember, if working in Painter, do not rescale the floater in the background because it was created from a painted mask!

Step 10 ➤

Paste the author's name a group of two floaters in the background as well. Study the colors. Because the background contains other colors, the gold in the author's name might seem lighter. In this case, ungroup the floaters, select the

appear; enter an amount. This might be limiting because this option does not allow alteration of the aspect ratio and the center. For total freedom, ungroup; rescale one floater using the corner handle; note the number; then rescale the other floater. Reposition and regroup.

A Collection of Writings Influenced by Daheshism

Step 11

To create the paragraph indentation in Painter, activate the grid. First, in Canvas: Grid Options, enter the size appropriate to the point size. In this case, the grid lines were set apart 120 pixels, and the point size was 24. The indentation is easy. After typing one line, point the cursor at the intersection of two grid lines. In PixelPaint, make the indentation in the Text Editor window, just like in Photoshop.

Step 12 ➤

The assembled piece consists of a background and three groups of floaters. Save it in RIFF, if in Painter, or PixelPaint Pro format if in PixelPaint. Each is a proprietary format that allows the software to maintain active floating selections. Remember to drop the floaters before printing directly from these formats, or they will not show up.

Skywriting
Technique: Wet-on-Wet, Virtual Trace Paper, Painting
Words, Digital Collage, Painting Photographs
Debi Lee Mandel

Cat-Sprite
Technique: Wet-on-Wet, Virtual Trace Paper, Painting Words, Digital Collage
Debi Lee Mandel

Wordsay
Technique: Wet-on-Wet, Painting Photographs, Painting Words,
Debi Lee Mandel

Sensory Overload
Technique: Painting Words, Digital Airbrush, Painting 3D Images, Painting
Photographs
John Derry

Maritime Poster
Technique: Painting Photographs, Wet-on-Wet, Painting Words, Digital Collage
Philip Howe

Buffalo Roam
Technique: Digital Airbrush, Painting Photographs, Painting Words, Wet-on-Wet, Painting 3D Images
Dewey Reid for Colossal Pictures

RKO Pictures
Technique: Digital Airbrush, Painting Photographs, Painting Words, Wet-on-Wet, Painting 3D Images, Virtual Masking
Dewey Reid for Colossal Pictures

Black Nightingale
Technique: Wet-on-Wet, Virtual Masking, Painting Words
Mario Henri Chakkour

THE KING'S SINGER

BY APRIL G. SHELFORD

The King's Singer
Technique: Digital Airbrush, Painting Photographs,
Painting Words, Wet-on-Wet with Virtual Masking
Caroline Meyers for O•Town Media

THERE HE WAS, STRANDED IN AN ISLAND
OF MOONLIGHT, LAUNCHING A NOTE, A
PHRASE, AN ARC OF SOUND, ALL EQUALLY
BEAUTIFUL, ALL TERMINATED EQUALLY
ABRUPTLY. HIS SECRET TERROR WAS
EVIDENT IN THE TENSED MUSCLES OF
HIS BACK, HIS GRIP ON THE LUTE'S NECK.

The Singer Loses His Voice
Technique: Digital Airbrush, Painting Photographs,
Painting Words, Wet-on-Wet with Virtual Masking
Caroline Meyers for O•Town Media

SING FOR ME, THE SINGER SAID, SING FOR ME NOW.
ALTHOUGH THE SON DID NOT DESIRE TO SING, HIS
FATHER'S VOICE WAS SO IMPERIOUS -- NOT FROM
RULE, BUT FROM SUFFERINGS THE SON HAD ONLY
HEARD RUMORED -- THAT HE, HEART ACHING,
BEGAN TO SING.

The Singer Dies
Technique: Digital Airbrush, Painting Photographs, Painting
Words, Wet-on-Wet with Virtual Masking
Caroline Meyers for O•Town Media

Reebok 100 #3
Technique: Painting Photographs, Painting Words, Painting 3D Images
*Graphic Design by Stoltze Design, Design and Production
by Planet Interactive*

Chinese Ghost Warrior
Technique: Wet-on-Wet, Painting Words
Romeo A. Esparrago, Jr.

Planet Interactive Demo Interface
Technique: Painting Photographs, Painting Words
Painting 3D Images
Planet Interactive

Olympic Logo
Technique: Digital Airbrush, Wet-on-Wet, Virtual Trace Paper,
Painting Words, Digital Collage
Scott Fray

Providence
Technique: Painting Photographs, Painting Words, Wet-on-Wet, Digital Collage
Ellen Watt for Iridian Grafax Net

Painter 3 Can
Technique: Digital Airbrush, Painting Words
John Derry

Tabac
Technique: Wet-on-Wet, Painting Photographs, Painting Words, Digital Collage
Steven P. Goodman

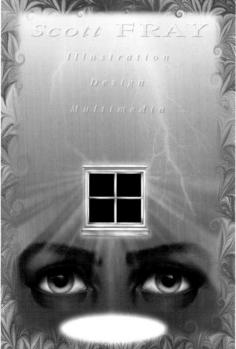

Eyes of Blue
Technique: Digital Airbrush, Wet-on-Wet, Virtual Trace, Painting Words
Scott Fray

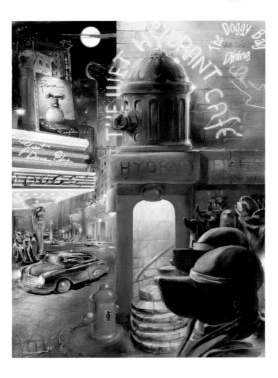

Dogville

Technique: Wet-on-Wet, Virtual Masking,
Virtual Trace Paper, Digital Airbrush,
Painting Words
Mario Henri Chakkour

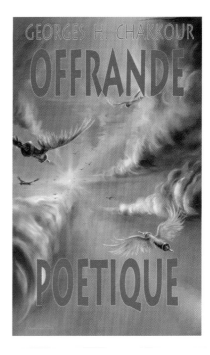

Offrande Poetique

Technique: Wet-on-Wet, Virtual Masking,
Virtual Trace Paper, Painting Words
Mario Henri Chakkour

Grounder

Technique: Wet-on-Wet, Virtual Trace
Paper, Virtual Masking, Painting
Photographs, Painting Words
Richard H. Biever

ANIMATION CELS

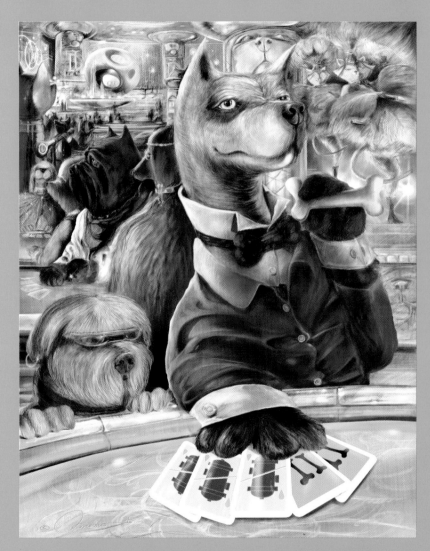

& CARTOONS

Bonefinger Mario Henri Chakkour

■ Typically, animation requires a team effort—a producer, a director, animators, cleanup artists, tracers, pencilers, inkers, and painters. On the other hand, many award-winning animations are the result of one person's work. Whatever the scale, a successful piece of animation requires some basic ingredients: a story, a vision, and an understanding of movement.

When computer-generated animations appeared, some were amazing. So amazing, that for a while some thought the advent of computer-styled 3D animation would render traditional animation obsolete.

The computer is more powerful than people as a processing machine and can render and animate quite realistic images. But it can only cover a limited range of the visionary spectrum. Computer-sculpted, mapped and animated anthropomorphic figures are cold, period. Today, hand-drawn animation is stronger than ever and has proven itself irreplaceable as an art form because of the range of interpretation it can convey. These are not only traditional cels but also paintings that move. Of course, powerful computers used strategically can be combined with hand-drawn cels to provide illusions impossible to achieve otherwise.

This section takes advantage of the computer to provide the artist with an affordable animation studio. The exercise shows how to create and animate a traditional-looking animation cel. The object is to think hand-drawn and hand–colored.

While Painter is the primary software for drawing and painting, The Animation Stand and Ink and Paint by Linker Systems are highly recommended tools and are presented here as well.

While the computer can automate certain chores, animators will always use animation stands to generate initial drawings. Such stands allow artists to work on several pages simultaneously which helps assure smooth movement. In fact, a patient artist can develop initial sketches directly on the computer, as shown in this exercise.

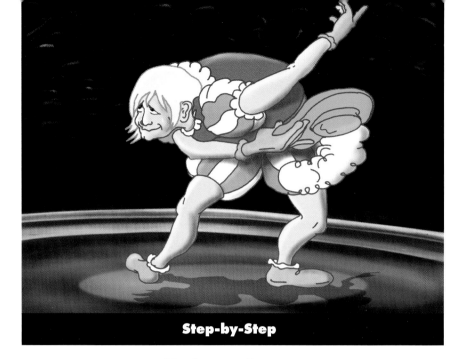

Step-by-Step

Take a Bow

Software: Painter 2.0 X2, 3.0 or later, and Adobe Illustrator if using Painter 2.0 and 2.0 X2 for creating Bézier curves, or Linker Systems The Animation Stand

Hardware: Apple Macintosh Quadra 700, 20 MB RAM, 230 MB hard drive, Sony 16-inch monitor, Apple 13-inch monitor for palettes, 24-bit color, Wacom ArtZ Tablet (8.5" x 6")

Image Size: Initial sketch is 640 x 480 pixels. Image is then scaled up to 1200 x 900 pixels before execution.

The brushes used in Painter include:
- Chalk (Chalks: Sharp Chalk) for rough initial sketching and composition.
- Charcoal (Charcoal: Soft Charcoal) for developmental sketching and rough massing of colors.
- Water (Water: Just Add Water) for blending colors, washes, form definition, and atmosphere.
- Total Oil Brush (Liquid: Total Oil Brush) for elaboration and fine details.
- Airbrush (Airbrush: Fat Stroke) for soft color build-up, glazing, elaboration, and fine details.
- Distorto (Liquid: Distorto) for character and effect.
- Scratchboard (Pens: Scratchboard) for trace-overs.
- Flat Color (Pens: Flat Color) for inking.

columbus three a vou.

Step 1 ▲

In Painter (or The Animation Stand) start with a 640 x 480 pixels white page. With the Chalk tool (or Free Draw tool in The Animation Stand), sketch the figure as it would appear in the first position, standing with arched back and stretched arms. Then, using different colors, sketch the last position. Anticipate how the legs, arms, and head will move. Some parts of the body will translate, others will rotate, and some will do both. Go over the figure with different colors, and draw more information on the sheet to suggest movement, such as the arms at key positions. The key here is to create a multiple-exposure image, a strobe-photograph-like sketch.

Step 2 ↓

Now that the first sketch is finished, it is time to simulate a light table. Make a trace-over of the figure standing up. Use the Scratchboard tool with black pigment as outlined in Section Four and select File: Clone: Select All: Delete. Click the Tracing Paper button. The drawback to this method is that

the opacity of the sheet of trace is preset. To avoid this, Select All: Float and decrease the opacity of the floating to reveal the blank white page underneath. Deselect the floater and draw as usual. A drawback to both methods is that the lines underneath are affected by the opacity level of the sheet on top. Incidentally, while each of these virtual tracing methods has its draw-

backs, it presents advantages as well; for example, imagine floating several layers of sketch paper, or onionskin. Creating the initial sketches at a very small size may also help alleviate system sluggishness.

At this point it is time to set up a streamlined system. Create a new folder called Pencil Lines, where the first rough cels will be placed in sequence, numbered one to nine. Once the sheet of trace paper is activated, select the Scratchboard tool and the color black. Trace the figure standing and stretching its arms. Save as File One in the Pencil folder. Put two spaces before typing "1" so that the numbered files the frames can be saved in their proper sequence. This becomes a factor when the number of frames is ten or above.

In The Animation Stand, the method is somewhat different. Save the first drawing and call it Sketch. Open a new image by choosing File: New. Then select your sketch, which will be used as a light table image, by choosing Options: Light Table. Choose your sketch file from the dialog's Light Table A menu. Choose an opacity level while in the dialog box and click OK. Draw, using any tools and colors; notice the light table image through your drawing. To dismiss the light table, choose None for Light Table A.

Step 3 ↑

Close the clone, or in the case of a floater, simply discard and repeat the procedure in order to trace the last position. Do not be afraid to draw more lines than necessary at first. Save as File 9 in the Pencil folder. Again, put two spaces in front of "9".

In The Animation Stand, repeat the process for drawing File 9. Don't worry about spaces in the names.

Step 4 ↗

At this point, motions are emerging. In a new file, the same size as the initial sketch, copy and paste the two positions consecutively. Remember to enter "0,0" for the top and left coordinates in Object: Floaters List. Now, both floating, select one of them and with the Floating Selection tool in hand, slide the opacity slider back and forth, and watch for mistakes,or unnatural-looking movements. To add or subtract lines, choose the layer in question and correct with the Scratchboard tool. Once satisfied, generate masks using luminance, and colorize the ink lines for later use, as explained in Section 4. Now there are two sketches float-

ing, one on top of the other, each a different color and capable of changing in opacity. Another quick way to do a page flip, which is where the numbering comes into play, is to choose File: Open. Painter's dialog box will appear, showing a thumbnail of images saved in Painter. Select the Pencil folder. The first saved image will appear in the Thumbnail window. Toggle the up and down arrows for a

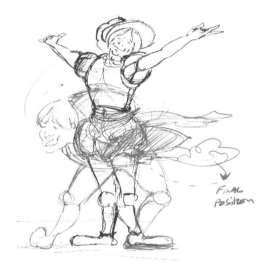

quick preview. This method comes in handy when several files are present and it is the fastest way to simulate what seasoned animators call a *Leica reel.*

In The Animation Stand, toggle back and forth quickly between the various open drawings by selecting Animate: Page Flip. Click the mouse to stop the page flip. Correct drawings as needed to make motion more fluid.

Step 5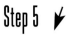

Now it's time to draw the middle position. Deselect both floaters after setting the proper opacity level; then, using the Scratchboard tool, loosely rough in the middle sequence with black. The method is time-consuming; however, compared to creating the same sequence using analog means, it is a breeze. When the beginnings of a good drawing are close, clone the image floaters will not be affected and Select All: Delete. Click on the Tracing Paper button. Trace a cleaner version, then save as File 5. Check the animation in the Thumbnail window again.

In The Animation Stand, two light table images can be activated at the same time. Sometimes, it is more useful to look at the base sketches and the previous drawing; other times, the boundary frames provide more guidance. For instance, for the fifth drawing cel, it might be more useful to look at cels one and nine. Decide on the cel or cels that will serve as a basis and select those drawings into the light table using the Light Table dialogs, Light Table A and Light Table B menus.

Draw frame three, then seven. That leaves two and four distributed around frame three, then six and eight distributed around seven.

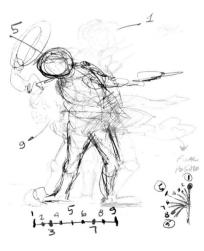

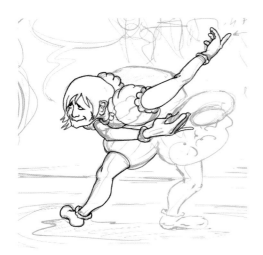

Step 6

When it's time to ink a penciled cel, clone it and choose Edit: Select All: Delete (Section Four) and click on the Tracing Paper button, or float the penciled cel and reduce its opacity to reveal the now-empty white cel below. Incidentally, unlike Sections Four and Seven, do not undo after floating. Next, use the Pens: Flat Color brush and set the Size to five. Leave the lower slider of the Brush Controls: +Size palette at full left and use the color black. This brush is not pressure-sensitive and should stay that way if a rapidograph effect is called for. Now carefully go over the pencil lines. One thing to remember: If using the Fill Bucket ink lines must not have any breaks.

The Animation Stand users should ink and paint their cels here as well. Close all of the open cels and the sketch. Then use File: Open to open the first drawing. Colorize any lines that need it by choosing the Line Color tool and painting over the lines in any

chosen color. Only the lines will be affected; the line texture and shading, if any, will remain intact. To insure that there are no breaks in the lines, choose Patch Lines from the Effects menu. Go on to the next cel with File: Next Cel.

Step 7

When done inking, discard the floater. To paint the cel, cover the ink lines with a mask by selecting Edit: Mask: Auto Mask: Image Luminance. Use the visibility buttons in Objects: Paths List

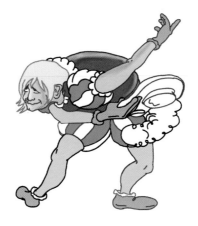

to control the mask: With the bottom middle and upper middle Visibility buttons on, the ink lines are protected with the mask and will not be painted over. Use that setting to paint within the lines. To repaint ink lines with different colors, click the upper right Visibility button. To flood paint within the lines, select the Fill Bucket tool and Cartoon Cel under What to Fill in the Controls: Paint Bucket palette. Point and click in the area of the hair. Does

it flood the whole page instead? If so, there is a leak somewhere. After checking for leaks, cover with black and regenerate the mask. If that does not remedy the situation, the ink lines may be too thin. Double-click on the Fill Bucket tool in the Brushes palette and slide the mask threshold to about 30 percent. Try it now. If some white shows between the ink lines and the color, reset the threshold toward the left: Proceed to fill in colors. Because of the limitations in Painter, use Ink and Paint by Linker Systems. For perfect results, the ink lines must be black; changing the color of the ink after the mask is created should not take long. Use the Visibility buttons as indicated above. Also, note the addition of airbrushed strokes to add that extra level of depth.

In The Animation Stand, select Clear All from the Edit menu to start the Auto-Painter with a clean slate. Open the first drawing. For each area to be painted, select a color and use the Paint Bucket to paint, clicking near the center of each area to be filled. If line texturing was used, use Paint Behind Bucket (the one with the green background in the Paint Bucket group). This will preserve line texturing and control shading at the line's edge. If so desired, paint an additional shading layer (using the Paint Bucket) with various Fall-Off and/or Ramp modes. When finished, use Next Cel to go on to the second drawing. Rather than painting the second drawing from scratch, click Auto-Paint (the small Paint Bucket with the pink background in the Paint Bucket group). The drawing will be painted for you. Use Next Cel to advance through the set.

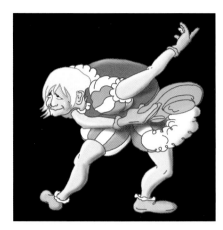

Step 8

To create a finished cel in Painter, first fill the hair with a lemon yellow. Then, with the Airbrush, and the Ink Pen, apply highlights. Reverse the mask. With the Ink Pen and olive green, carefully go over the outline of the hair. The rest of the body receives a light crimson. Reverse the mask, fill, and airbrush the other areas. Note that because the inked line in each eye is not enclosed, the resulting mask must have had a hole or a leak: Correct with white. If the area in question is too large to fill in by hand, use the Masking Brush (Section Eight) to close the mask. Fill the background with black.

To fill the next cels with the same colors, create a color set by first selecting the Window: Color Set palette. To customize, choose Window: Art Materials: Sets and select New Set. Using the Eyedropper tool, point at the yellow in the hair and press the Add button. The color is now catalogued in the Color Set palette. Double-click on the palette and enter the name of the color. Repeat for all the others.

Step 9

Now that a cel is created, place it over a background in this case, a circus scene to make one frame. To create a background in Painter, use the wet-on-wet and masking techniques. Open a new 1200 x 900 pixel, purple-black page. In the upper two-thirds of the page, using the Soft Charcoal tool in a slightly lighter color, apply gentle brush strokes to suggest light bouncing off spectators. In the bottom third, mass out purple,

orange, and a little white with the Charcoal. Then, using the Just Add Water tool, blend together. For the edge of the rink, apply broad strokes using red, yellow, and a little gold. Then follow with broad Water strokes. Of course the background can be generated in a program such as StrataVision 3D, as shown in the final section.

Step 10

Flesh out the edge of the rink by masking or even better, floating. First, using the Bézier selection tool, create a path (shown as marching ants A), feather, and float it (remember to undo). Then generate the second path (shown as inactive Path B) and float it as well. Note that Paths A and B overlap. To move A over B, select the Floating Selection tool, which activates Controls: Floating Selections; select Floater A; and push the Front button. With Floater A selected, choose the Airbrush and apply broad strokes of light gold, followed with darker tones. Enrich with purple and white highlights. Move on to the lower Floater and follow the same procedure. The advantage to floating here is that the artist can alternate between segments without worrying about the Visibility buttons. Introduce the Water tool set at low opacity to break monotony. Follow with a thin Total Oil Brush.

While in Painter, the various layers are merged into frames as a paint step; in The Animation Stand,

create as an animation by following these steps: Create a new exposure sheet using File: New Film. Click once on the End of Film marker to establish a working position. Use Animate: Add Layers to add layers. In the dialog that appears, ask for nine frames of two layers each. Eighteen new exposure sheet lines appear. Double-click the first File field in the sheet to select the background. The Open dialog will appear. Select the background (the circus rink). Press "0" eight times to copy the background into the other eight frames. Double-click the second File field in the sheet to select the first (only in this example) cel layer. In the Open dialog that appears, select the first drawn cel. Press "+" eight times, loading in the rest of the drawings. You may now use Animate: Play to view the animation so far. Since the drawings are separate, artists can still make changes to the background or cel art without having to worry about reconstituting frames.

Step 11

Now the background is done, open the cel we left behind in Step Eight and select Edit: Magic Wand. Wait for the Magic Wand dialog box to appear. Click on the black area surrounding the figure and press "OK." Two masks appear. Check Objects: Paths List. A mask group is now present, containing two negative masks. Select the mask around the figure; point and click with the pointer or highlight the name in the Objects: Paths List. Then press the "+" button to turn it into a positive mask. Next, select the floating selection tool and

float the figure. Copy and paste in the background. Reposition the cel—now a floater in the background—by entering the right coordinates (Section Seven).

There is no need for masks in The Animation Stand.

Step 12

To create the spotlight, select the Circular Selection tool and make an elliptical selection by pointing and dragging the cursor. Marching ants will appear. Move the pen around to get the right form and release. Once the elliptical selection is satisfactory, using the Visibility buttons, feather the edge well. Reselect the Pointer tool and then the Floating Selection tool. Point and click on the ellipse and select Undo. Now there is a floating ellipse that contains pigment lifted from the background. Fill it with white using the Fill Bucket tool. Then reduce the opacity. For the shadow, repeat

the procedure, but use the Freehand Selection tool and feather much less. Fill with black/purple. Reduce the opacity and drop all floaters, after making sure each of the Above/Below sequences is checked.

Congratulations! One of many frames is done.

To make a spotlight in The Animation Stand, first create a black background in a new cel with a dark, feathered gray on top of that. This will be the double exposure mask. Save it as Spotlight. Go back to the exposure sheet and double-click in the Frame field of the first frame, to the left of the last cel. This will open up a new layer between the figure and the rink. In the first newly created File field, double-click to select the spotlight. Then add Glow to the Notes field for that layer to create a glow effect for that frame. Copy the layer into the clipboard, and for each subsequent frame, select the figure layer, using Edit: Paste Before to add the spot. Now the spot is in the same place in all nine frames. Click on the first frame, and then go to the Current Frame window. Click on two, the spot layer, and drag it to the desired area in each frame, using the Next Frame button to advance to the next. Use Play to see the revised animation.

*Since the writing of this book, version 3.1 of Painter was released, requiring the following update regarding floating selections. If using version 3.1 to get rid of the halos, follow this procedure: Make a scratch copy of the original painting; float the selection; note the coordinates of the floaters; copy floaters; paste floaters in scratch file. That will take care of the halo effect.

Discovery
Technique: Animation Cels
Kurt Wiley

Anna & Otto © 1994 K.Wiley

Rachel's Friends
Technique: Animation Cels
Kurt Wiley

Devil in Disguise
Technique: Animation Cels
Mario Henri Chakkour

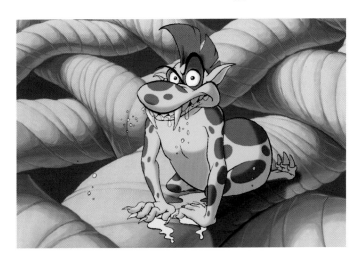

Cloralex Still 1
Technique: Animation Cels
Ron Price

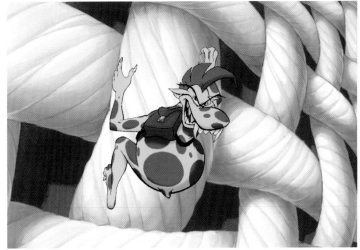

Cloralex Still 2
Technique: Animation Cels
Ron Price

Cloralex Still 3
Technique: Animation Cels
Ron Price

Ruby, Frame Six 6
Technique: Animation Cels
Creator and Artist Michael Emberly, Design and Production by Planet Interactive

Ruby's whiskers twitched. Out in the kitchen, Ruby's mother was just finishing a batch of her famous triple-cheese pies. "Ruby!" her mother called.

THIS WAY ? QUESTIONS RUBY THAT WAY

Ruby, Chair
Technique: Animation Cels
Creator and Artist Michael Emberly, Design and Production by Planet Interactive

Sunrise
Technique: Animation Cels
Mario Henri Chakkour

Frozen Tomato #2
Technique: Animation Cels, Painting Words,
Painting 3D Images
Planet Interactive

Frozen Tomato#1
Technique: Animation Cels, Painting Words, Painting 3D Images
Planet Interactive

PAINTING

VECTORS

The Living Watchtower *Ellen Watt for Iridian Grafax Net*

■ Most of the images in this book were created from scratch, using the computer as if it were a traditional painter's medium. The results vary from free and painterly to slick and precise. The level of precision is a result of drawing and masking tools and careful planning. The methods shown reflect traditional processes such as airbrushing. This may not be practical for some uses, such as creating complex renderings. Again, vectors come into play.

The terms 2-D and 3-D as they apply to images on the computer are misleading. The perception of 3-D space does not depend on whether vectors were used. Does a cube created in StrataVision and viewed in "Orthographic View" mode (non-perspective projection) look three-dimensional? Of course not. A couple of quick sketch marks made by a master may reveal a lot of depth.

In the world of industrial design and architecture, time and money require computer-generated, vector-based images to effectively communicate 3-D models. The process is divided into three phases: conceptual, modeling, and rendering.

In the conceptual phase, the sketches are created and scanned into modeling software, where a model is extrapolated in the modeling phase. There are two primary categories of modelers, surface and solid. Surface modelers build skeletons of objects that are later covered with "skin". Solid modelers, on the other hand, build solids and combine and/or distort them to extrapolate forms. Once created, models are imported into rendering software as photorealistic images. There, users map textures, apply lighting, and position cameras.

Most desktop 3-D renderings display minor imperfections such as jagged edges and sterility. The rendering must be retouched to bring it to life.

This assignment shows how to create a rendering of a museum lobby. Because RAM and CPU power are severely taxed by the model/render process, each piece will be rendered separately.

The Museum Lobby

Software: Painter 2.0 X2, 3.0 or later, and Adobe Illustrator if using Painter 2.0 and 2.0 X2 for creating Bézier curves, DesignCAD, Strata Vision 3d

Hardware: Apple Macintosh Quadra 700, 20 MB RAM, 230 MB hard drive, Sony 16-inch monitor, Apple 13-inch monitor for palettes, 24-bit color, Wacom ArtZ Tablet (8.5" x 6")

Image Size: 1200 x 900 pixels

The brushes used in Painter include:

- Chalk (Chalks: Sharp Chalk) for rough initial sketching and composition.
- Water (Water: Just Add Water) for blending colors, washes, form definition, and atmosphere.
- Total Oil Brush (Liquid: Total Oil Brush) for elaboration and fine details.
- Airbrush (Airbrush: Fat Stroke) for soft color build-up, glazing, elaboration, and fine details.
- Distorto (Liquid: Distorto) for character and effect.

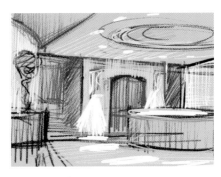

Step 1

Step 2

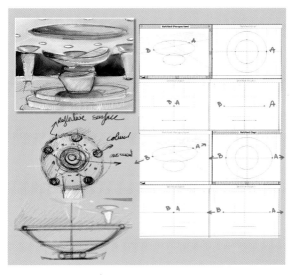

Step 3

On subsequent pages, develop sketches for individual elements the sconce and a sculpture, for example. For the sconce, draw a vertically elongated cube. Then study how the geometry must shift to create the object. That will determine which software to use for the modeling. So far, the sconce seems best suited for a solid modeler, considering the bottom part, which will be created by subtracting a sphere from a sliced cube. The housing for the light, a rounded, conical shape, may be generated directly in StrataVision 3-D by lathing an EPS curve drawn in Illustrator. A preliminary rendering was created in Strata Vision 3D, and now it's ready for the hard manipulation in DesignCAD, a powerful skin modeling application.

On a new 1200 x 900 pixels sheet, and using a wet-on-wet approach, sketch a general view of the lobby. Using the Sharp Chalk brush, with the help of the Rolling Edge, draw some vertical lines. With the ruler, draw perspective lines. In a freehand, circular motion, rough in the indication of a dome. Draw the space around a rotunda. Make a central wall with an arched opening. On each side of the door, rough in the indication of wall sconces. After that, using pure white, rough in light wash under each sconce. Still using the Chalk, indicate recessed lighting. Follow-up by rubbing white ellipses on the floor to indicate the light spots.

More complex forms could take a long time to create. Then again, DesignCAD, has some very powerful modeling capabilities. Try this: Start the Design toolbox and choose the 2-D Solid Circle. In the Top View window, draw a circle. Choose the Object Center tool. Position the cursor in the center roughly and draw a smaller circle; both will be centered. Select the smaller circle with the Relocate (cursor) tool. In the Front window, and while pressing down the shift key, drag the smaller circle below. Next, using the Tilt tool, select Point A. (The Tilt tool allows selecting individual points without selecting the rest of the points on the object). Still with the Tilt tool, in the Top View, click on Point A and drag it to the right, without releasing the pressure. Now press down the shift key while dragging to constrain the movement to the horizontal. Repeat with Point B, except this time drag to the left.

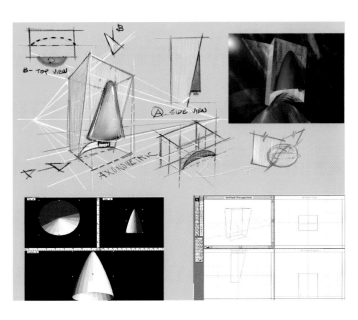

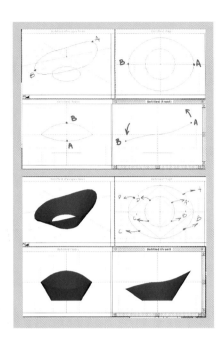

Step 4

Still using the Tilt tool, select Point A. In the Front View, move it up. Select B and move it down. What follows is a very powerful modeling act: Select the 3D-Ruled Surface tool: Viewing the two circles in the Top View, click on sides A, A', B, B', C, C' in sequence. Note the appearance of a red line each time two sides are clicked in sequence. To see the result of what just happened, render. A skin should now stretch between the circular planes. Place a cylinder using the 3D Solid Cylinder tool.

Step 5

Using the Tilt tool again, select and move points on the upper cylinder and connect them to corresponding points on the base below. Render and check

progress. Place another cylinder, this time in the Front View. To elongate it, simply use the Tilt tool to select the four points on either side. Then, in the Top View, click and drag on one of the selected points. While still pressing down the shift key, stretch the cylinder. Reposition over the base. Select Point E with the Tilt tool and drag in. Repeat with Point F.

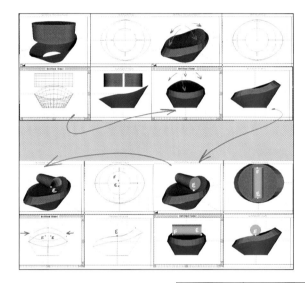

Step 6 ➤

In the Top View, reduce the zoom factor to make way for the additional information to be placed. Next, using the 3D Solid Cylinder tool again, create another cylinder. Move it above the present assembly.
Following the steps above, use the Tilt tool to select points (preferably in the

Perspective View first), then proceed to stretch and mold the upper portion. The modeling is done. Because the rendering will be done off-site in StrataVision 3D, separate the three sections by clicking in each with the Relocate tool. Save the file. Next, using DesignCAD Exporter, choose Format: DXF. Also increase the Patch Smoothness depending on system capabilities. Select Edit: Translate and then translate the current DesignCAD file into DXF format. Open the file in Strata Vision 3D. The reason for physically separating the three segments of the object will then become obvious: The object is imported with literally hundreds, if not thousands, of points. Select and group each cluster of points. Then reassemble the pieces.

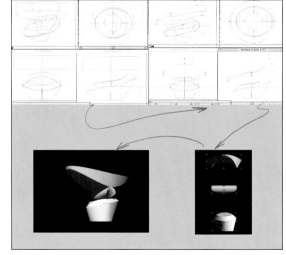

Step 7

Now that the sculpture is assembled, create a base for it using either the 3D Cylinder tool or the 2D Oval tool. With the latter, extrude afterwards (please refer to the manual). Applying textures is rather straightforward in StrataVision 3D; the hard part is making these textures look like they are supposed to, which can be helped with lighting. Certain surfaces work better if reflecting multiple sources of light. The rendered sconce in Step 2, for example, reflects light bouncing off a chrome wall erected in front of it. Repeat the same thing here. First, while in Top View, draw a freehand spline using the Freehand Line tool in the 2D Objects tools, then extrude the line into a wall. Place a combination of Point Spot lights, for example, underneath the base, facing the wall. Turn them up 60 degrees and slide the base away from the undulating wall to

allow the light from the spots to wash it. Create the dome by lathing a spline (a quarter-circle-like line with ridges in the middle) drawn in Illustrator and imported into Strata. Render the view. By now, the limitations of average desktop computers are becoming obvious: It takes a long time to render and RAM has reached its limits. That is why sometimes a montage is called for (e.g., importing the sculpture into another 3-D rendering); otherwise, the system couldn't handle the load.

Step 8

The following steps will address common problems with so-called "photo-realistic renderings". As explained above, rendering a complex image that contains many imported objects takes a long time. The alternative? Create a series of lower-resolution renderings and retouch them, just as in Section Six. Retouching and collaging also will produce better results because of the certain inadequacies inherent in 3-D modeling software, such as glow from a recessed light. Take the following rendering created after the initial sketch in Step One. Each element is easy enough to create, yet there are some major problems including jagged edges, recessed lights with no glow and a rendering that might tie up the average sys-

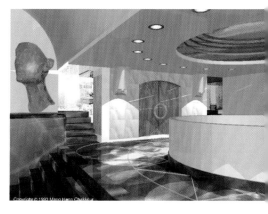

tem for a week running full-time. Besides that, where are the people? These last few steps synthesize all the knowledge gathered in this book. First, open the image in Painter and treat it as a painting. Create masks for every element that needs retouching. Rescale the image up and treat it as a rough painting. Now create masks for all the objects that require it. Create several scratch copies of the file. In each copy, isolate (mask or float) the objects to be retouched. Import them into the final piece.

Step 9

After masking every element, smooth the dithering by using the Just Add Water tool set at 20 percent opacity. Gently smooth away as much as possible before the image looks more painterly than photorealistic. The Distorto tool adds special effects, but remember to use it in moderation. Apply Distorto after smoothing the ceiling. Next, apply the Airbrush to add the glow to the recessed lights. Last, and depending on the style, scan-in or render-in people to provide scale.

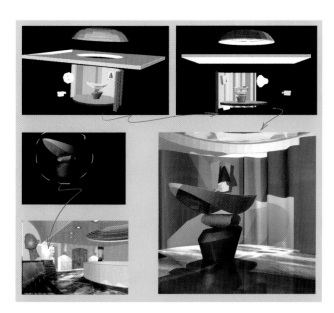

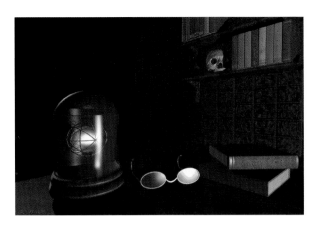

Bell Jar
Technique: Painting 3D Images
John Sledd

Twin Towers
Technique: Painting 3D Images
Dewey Reid for Colossal Pictures

Hive
Technique: Painting 3D Images
John Sledd

Lobby
Technique: Painting 3D Images
Dewey Reid for Colossal Pictures

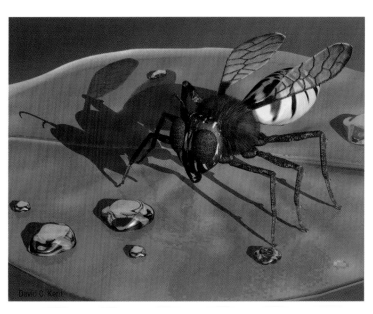

Wasp on Lily Pad
Technique: Painting 3D Images
David C. Kern

Hottub
Technique: Painting 3D Images
Derrick Carlin

Multimedia
Technique: Painting 3D Images, Digital Collage, Digital Airbrush
Henk Dawson

Iridian on HoloVuer #2
Technique: Painting 3D Images
Ellen Watt & Jimmy Reynolds for Iridian Grafax Net

IGN Logo with Iridian
Technique: Painting Words, Painting 3D Images
Jimmy Reynolds for Iridian Grafax Net

Iridian on HoloVuer #1
Technique: Painting 3D Images
Ellen Watt & Jimmy Reynolds for Iridian Grafax Net

Glass Bubbles
Technique: Painting 3D Images
Richard Lainhart for O•Town Media

MediSense
Technique: Painting 3D Images
Planet Interactive

Woodland Dreams
Technique: Painting 3D Images
Joseph F. Mack

Egyptian Temples
Technique: Painting 3D Images
Dewey Reid for Colossal Pictures

Appendix A

The exercises in this book focus on the process of artistic creation as well as the nuts and bolts of the software. Even ace pilots need to know what each little knob is for so they don't eject themselves by mistake. Read as much of the manual as possible. Also, do not be obsessed with this or that. Experiment. Here, Painter 2.0, 2.0 X2 or 3.0, and PixelPaintPro 3 are used to introduce the artist to different painting environments. PixelPaintPro3 was chosen because it set the standard for all painting software, such as Photoshop, that resist visually emulating the "natural" environment. Each painting example has its strengths and weaknesses, and no studio should ever rely on just one.

What about drawing programs such as Adobe Illustrator? How are they different than painting programs? What is PostScript? First, Painter and PixelPaint create and manipulate pixels whose number determines the quality of the output. Adobe Illustrator, on the other hand, creates resolution independent images using a language called PostScript, generally referred to as a page description language, to create vector images. Vector images are files that rely on mathematical functions (formulae) to describe lines and curves. They may be enlarged or reduced in size without suffering any loss of quality in their output. PostScript is only one of many drawing languages.

A Word About Printing Computer Paintings

Software and machines are faster and smoother, and they will only get better. Also, the introduction of frequency modulated (FM) or stochastic screening, and hi-line screening will make it possible to generate halftone screens of higher resolution from comparatively lower resolution digital files.

Traditionally, the digital artist works at a resolution of 300 pixels per inch (ppi) if the line screen frequency required for output is 150 lines per inch (lpi) common for offset printing. This means that to print an image whose final size is 4 x 6 using a screen whose frequency is 150 lines per inch, the artist is expected to supply 1200 x 1800 pixels, or an image with a resolution of 300 ppi. What if the art needs to be twice as large? Remember, twice larger in size means quadrupling space on the hard drive, so artists usually rescale by interpolation doubling the number of pixels and making the computer fill in the blanks by guessing what colors the new pixels will be even though it destroys some tonal quality.

With FM (stochastic) screening, artists may now work at a resolution of 150 ppi or a 1-to-1 ratio. With hi-line, a .75 to 1 ratio can be achieved. In other words, a 15-MB painting can look like a 100-MB painting without rescaling.

When commissioned to create a publishable digital painting using halftones, the first questions should be: Who is creating the film, and what screening technology do they use? If the client is set on using a particular imaging center, bear in mind that interpolation might be the only way out. But limit the rescaling to 200 percent; then, if asked to submit a 120-MB painting, create a 30-MB painting and try to look innocent.

Appendix B

For the exercises in Painter 2.0 X2 or 3.0 and beyond, the main brushes are:

- Chalk (Chalks: Sharp Chalk) for rough initial sketching and composition.
- Charcoal (Charcoal: Soft Charcoal) for developmental sketching and rough massing of colors.
- Water (Water: Just Add Water) for blending colors, washes, form definition, and atmosphere.
- Total Oil Brush (Liquid: Total Oil Brush) for elaboration and fine details.
- Airbrush (Airbrush: Fat Stroke) for soft color build-up, glazing, and elaboration and fine details.
- Distorto (Liquid: Distorto) for character and effect.
- Pixel Dust (Pens: Pixel Dust) for stipple effect.
- Scratchboard (Pens: Scratchboard) for trace-overs.
- Flat Color (Pens: Flat Color) for trace-overs, freehand text, and animation cels.
- Soft Cloner (Cloners:Soft Cloner) for an airbrush-style cloning.
- Masking Pen (Masking: Masking Pen) for editing the mask layer.

Unless other variables come into play, a chosen brush size will remain constant. In Painter 3.0 (and subsequent versions), customize the following brushes by allowing the velocity and pressure of the stylus (pen) to vary such elements as the size of the stroke, its opacity, and whether or not it shows the paper grain, in addition to first setting the brush tracking, which allows the pen to be "tuned" to the user's hand pressure and velocity. In the same way, the strings on a guitar must be tuned after changing the height of the strings.

If this is still not clear, note when drawing with the airbrush how a little pressure on the tablet is enough to flood the page. Now open the Edit: Preferences: Brush Tracking window and draw a stroke with maximum velocity and hand pressure. Returning to the airbrush, note how the same amount of stylus pressure earlier results in less pigment. A lot more pressure

will be needed to achieve the same results without "tracking set-up."

By altering the expression with the Window: Advanced Controls: Expression (Sliders) palette, an artist may further tweak brushes.

For Sharp Chalk, Soft Charcoal, Just Add Water and Distorto:

1) Connect size to velocity.
2) Connect opacity and grain to pressure.

For Total Oil Brush:

1) Connect opacity and grain to pressure.

For Airbrush:

1) Connect size to velocity

Save the changes by selecting Tools: Brushes: Save Variants.

For additional customization, choose the Medium Profile tip in the Window: Brush Controls: Size palette to allow soft anti-aliasing at the edges. Size is best changed on the fly; otherwise, too many saved brushes will lead to confusion.

Other suggestions:

- Select paper texture in Window:
- Materials: Papers: Basic Paper.
- Read the manual.
- Forget Playback Sessions at higher resolution. For now, draw in real time.
- Set the pressure sensitivity of the pen using Tracking or Scaling.
- Select sizes intuitively.
- Select colors in RGB mode.
- Save As after the first Save operation in case the computer bombs in the middle of the saving operation.

Appendix C

In the digital world, there are a couple of ways to emulate tracing paper, or onionskin. The first involves cloning the image, as in Painter. Cloning, as the word suggests, creates a duplicate of the first image. Once a clone is created, the Select All and Delete commands will erase the cloned image, leaving only the background. Now click on the Tracing Paper button. The image reappears again as if shrouded in trace paper. Note that the background color of the new sheet of virtual trace paper is the same as the background color for the first image the of clone source. To change it, select all and use the Fill Bucket to flood the page with any color. (Incidentally, when choosing color using an HSV, pure white is hue zero and saturation zero).

Now click again on the Tracing Paper button. Notice that this is the equivalent of removing and replacing the sheet of virtual trace paper, or turning a light table on or off, a necessary technique when creating animation.

Another more general way of creating trace paper is to use the common Floating command available in most painting software. In Painter 3.0 or 2.0 X2 open a new file with the same size; select all and copy; select the original; zoom out to include the whole image on the monitor; and paste File 2. Quite literally, File 1 has an identical sheet of paper floating on top of it, that is opaque rather than transparent. Vary the transparency level using the opacity slider in the Controls: Floating Selection palette. Version 3.0 users should make sure the Floating Selection is chosen first. The magnification is reduced before pasting to make sure the overlaid image is centered exactly. Try it the other way. Paste the image now a floating selection and read the attributes (coordinates) in the floating selections dialogue box: They are not (0,0). Adjust them so that the image repositions correctly.

In PixelPaintPro 3, begin creating virtual trace paper by opening a new file, the same size as the original. Select all and copy, then paste to the original. Click on the Selection Mode button and select Pixel Layer On. Click on any selection tool button and reduce the opacity using the Transparency Control slider in the bottom left of the Tool palette. This is now a sheet of tracing paper. To draw or paint over it, select a painting or drawing tool. Note the Transparency slider will not move. Therefore, set it to the desired level say 100 percent; otherwise, the brushstrokes will not be fully saturated. To change the transparency of the page again, choose a selection tool and move the Transparency Control once more. When satisfied with the sketch, either copy and paste the floating layer onto a new file or drop it, but remember to set the desired transparency level.

The process can be repeated in Macromedia Xres and Photoshop 3.0. Simply set the layers and vary their opacity.

Acknowledgements

I would like to thank the following for their dedication and support during the creation of this book:

Stanley Patey for his depth of vision and for making this project a reality.

Arthur Furst for his dedication to this project.

Shawna Mullen for her editorial expertise.

Kathleen Kelley for a top-notch job of keeping track of all the details, large and small.

The rest of the cast at Rockport, for its superb job producing this book.

Communications specialist Joseph Selame, IDSA, for his expert advice and for suggesting the title of the book.

Award-winning digital artist and close friend Dennis Orlando for introducing me to many wonderful artists including Dorothy Simpson Krause and Gary F. Clark.

Dewey Reid for his contributions to digital painting.

Daryl Wise for his incredible help compiling a list of great contributors and contacting them on my behalf.

Kathi Jolley for her valuable assistance.

Donald Fluckinger for his help keeping the book on track.

Kate Binder for her expert advice.

Gregory Scott Wills, multimedia guru, for producing the companion CD.

Each artist whose work is featured in this book; without your support and generosity this book would not have been possible.

Last but not least, my wife for her patience, support and encouragement.

Richard H. Biever
117 N. Frederick
Evansville, IN 47711

Kathleen Blavatt
743 Sunset Cliffs Blvd.
San Diego, CA 92107

Steve Campbell
1880 Fulton #5
San Francisco, CA
94117

Derrick Carlin
Dynamix
1600 Millrace Drive
Eugene, OR 97403

**Mario Henri
Chakkour**
*Studio Twenty Six
Media*
209 West Central Street
Suite 210
Natick, MA 01760

Michael Cinque
P.O. Box 1322
Aptos, CA 95001

Gary F. Clark
823 Lightstreet Road
Bloomsburg, PA 17815

Henk Dawson
Dawson Design
3519 170th Place NE
Bellevue, WA 98008

Todd DeMelle
317 E. Charlton Street
Savannah, GA 31401

John Derry
Fractal Design Corp.
335 Spreckels Drive
Aptos, CA 95003

Scott Fray
51-A Woodbine Street
Kernersville, NC 27284

**Fox Advertising and
Marketing**
65 Eliot Street
South Natick, MA 01760

Kerry Gavin Studios
154 East Canaan Road
East Canaan, CT 06024

Steven P. Goodman
31 Elsom Parkway
So. Burlington, VT 05403

Andy Gordon
8001 Inspection
House Road
Potomac, MD 20854

Stacy A. Hopkins
2 Chippenham Drive
Newark, DE 19711

Philip Howe
Howe Computer Art
540 1st. Avenue South
Seattle, WA 98104

Planet Interactive
36 Drydock Avenue
Boston, MA 02210

**Romeo A.
Esparrago, Jr.**
1160 Alder Tree Way
354
Sacramento, CA 95831

David C. Kern
Pixel Pictures
11236 W LK Joy Dr. NE
Carnation, WA 98014

Stephen Kramer
Kramer Graphics
PO Box 599
Capitola, CA 95010

Dorothy Krause
Viewpoint
32 Nathaniel Way
Box 421
Marshfield Hills, MA
02015

Jonathan Krop
105 Joost Street
San Francisco, CA 94131

Susan LeVan
*LeVan/Barbee
Studio*
30 Ipswich Street
Studio 211
Boston, MA 02215

**Ed Lowe
Photography**
P.O. Box 84183
Seattle, WA 98124

Joseph F. Mack
Multi-Mac-Media
726 Schyler Court
Gahanna, OH 43230

Debi Lee Mandel
Rara Felis Studios
P.O. Box 2
Dutch Flat, CA 95714

O•Town Media
66 Pearl Street, #606
New York, NY 10004

Iridian Grafax Net
365 Orms Street
Providence, RI 02908

Dennis Orlando
79 Brookline Road
Ivyland, PA 18974

Ron Price
Character Builders
965 High Street
Worthington, OH 43085

Max Probasco
1001 Harness Lane
Richardson, Texas 75081

Jan Ruby-Baird
480 Crossroad School
Road
Carlisle, PA 17013

Victor von Salza
*Digital Photographic
Arts*
426 Mountain Laurel
Court
Mountain View, CA
94043-5500

Karin Schminke
5803 NE 181 Street
Seattle, WA 98155

John Sledd
*Ideo Illustration and
Design*
561 Harris Drive
Front Royal, VA 22630

Nancy Stahl
470 West End Avenue
8G
New York, NY 10024

Ayse Ulay
*Ulay & Ulay
Communications*
146 South Michigan
Ave. #101
Pasadena, CA 91106

Trici Venola
Trici Venola & Co.
911 Marco Place
Venice, CA 90291

Corinne Whitaker
The Digital Giraffe
P.O. Box 0-1
Carmel, CA 93921

Kurt Wiley
344 Mombray Road
Flat 7
Chatswood, NSW 2067
Australia